IMAGES
of America

MICHIGAN CITY
LIGHTHOUSE
GUARDIANS OF LAKE MICHIGAN

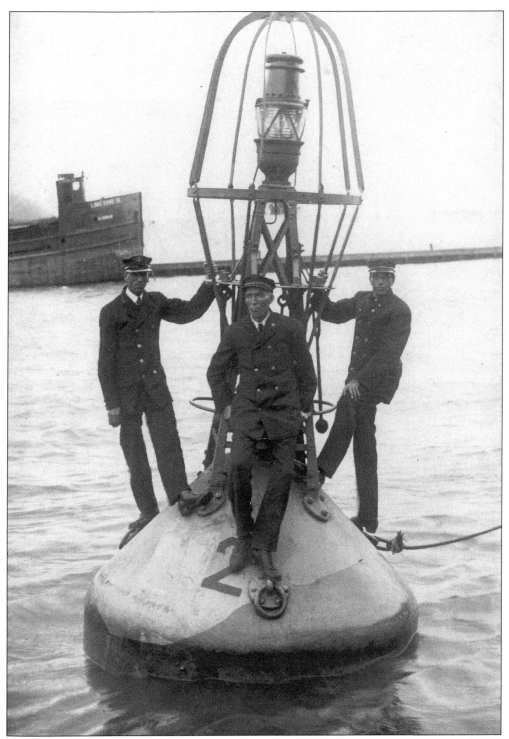

The three keepers of the Michigan City Light pose on the bell buoy. From left to right are Second Assistant Fred Dykeman, Keeper Thomas Armstrong, and First Assistant Thomas Martin. The sandsucker, *H. Dahlke*, is seen in the background.

IMAGES
of America

MICHIGAN CITY LIGHTHOUSE

GUARDIANS OF LAKE MICHIGAN

Steven D. Elve

ARCADIA

Published by Arcadia Publishing,
an imprint of Tempus Publishing, Inc.
3047 N. Lincoln Ave., Suite 410
Chicago, IL 60657

Printed in Great Britain.

Library of Congress Catalog Card Number: 2001086666

For all general information contact Arcadia Publishing at:
Telephone 843-853-2070
Fax 843-853-0044
E-Mail sales@arcadiapublishing.com

For customer service and orders:
Toll-Free 1-888-313-2665

Visit us on the internet at http://www.arcadiapublishing.com

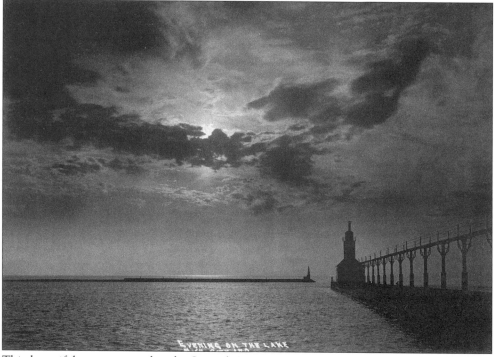

This beautiful sunset was taken by Second Assistant Keeper Fred Dykeman. The lighthouse keepers witnessed many scenes such as this one as they went about their duties at the light. One can see how the life of a lighthouse keeper could be seen as romantic. You almost want to travel back in time.

CONTENTS

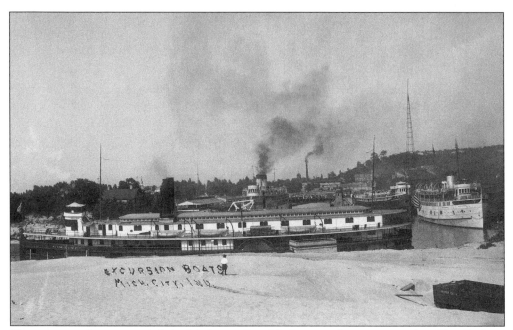

The excursion boats crowded the Michigan City Harbor on a busy summer day. The Graham and Morton steamer, *Holland,* is in the foreground with the *Roosevelt* on the left, in the background. In the right front is the *United States*, and the *Kansas* is behind her.

ACKNOWLEDGMENTS

Putting together a book can never be accomplished by a single person. It is the many willing individuals and institutions that bring together a manuscript.

I would like to thank Virginia Bushong, who gave us a wonderful tour of the Michigan City Lighthouse, and always had answers for the many questions I fired her way. Also, a special thanks goes to June Jaques, who is the director of the Old Lighthouse Museum in Michigan City. She allowed me complete access to their fine historical files, and was very accommodating to me during my research visits.

I am indebted to my Aunt Loie, Uncle George, and Marie (Mom), who put together the connection of Second Assistant Keeper Fred Dykeman's residence in their Grand Rapids neighborhood after his retirement from the lighthouse service. This really brought my research home and tied up some loose ends.

I would also like to acknowledge the special help given to me by Cathy Conklin, and Ken and Kathy Dahnke. They were the vehicles that kept this book going. Thanks also goes to Mrs. Deanne Kroon for making this book a reality, and encouraging me not to give up.

Last, but not least, many thanks to my wife Carol, who always went along willingly on my research trips and never complained, but was always a great source of encouragement.

INTRODUCTION

The writing of this book came about as an unexpected adventure. While browsing down the isles of a local flea market, I came across a group of lighthouse photos and postcards in a box. The vendor, Mrs. Deanne Kroon, related to me a wonderful story of how her husband's uncle was once the second assistant lighthouse keeper in Michigan City, Indiana. He had willed them a box full of postcards and photographs taken from 1909 through 1920. Since our meeting, we have become good friends. I feel a warm friendship in getting to know her uncle, Fred Dykeman, and Keepers Thomas Martin and Thomas Armstrong through the many, many photos they have given to history.

Today, lighthouses and their connections with maritime history have become a growing passion with people around the world. There is something romantic about the majestic sentinels, as they stand perched upon beautiful landscapes, protecting the mariners of yesterday and today. Who hasn't dreamed of being a lighthouse keeper and lighting off that beacon? Watching the beam pierce the pitch black sky and warning mariners away from the dangerous shoals and jagged rocks allows one to have a glimpse of being a guardian of the night seas.

Many lighthouses have fallen on hard times, as keepers are no longer stationed at these beacons, and a new era has brought in automation. The keeper has vanished from the scene! Some of these lighthouses have fallen into desolate, crumbling buildings, and towers have become endangered to total extinction. But there is good news! Many areas have rallied together to form groups to save these beacons. One such group is the Michigan City Historical Society. In 1965, they leased the old lighthouse from Michigan City with the agreement to restore it, and they have done it!

The lighthouse is built upon a hill along the channel. The station appears much today as it did back in 1858, when it was new. In 1988, the society went a step further and restored the East Pierhead Light Tower and the elevated catwalk. In putting together this book with all these vintage images, I couldn't help but reflect upon the keepers and how life must have been back then. Visiting the lighthouse and pier lights helped me to relive the era these men lived in. As I walked down the East Pier break wall, I visualized Fred or Tom walking down the same pier. Maybe a stiff wind was coming down the lake, blowing them up against the catwalk, the waves soaking their clothes as the wind whipped the spray over the pier. Finally they reach the access door to the tower and enter it. Upon climbing the steel stairway, they reach the lantern room, where the Fresnel lens stands upon its revolving pedestal. The bright beacon sends a piercing beam out, cutting into the solid black sky.

When a ship leaves the freedom of the open sea and enters territorial waters, the captain has to depend on the light from the lighthouse. The light casts out a beam of security and hope. It

is constant and sure. Its beam reaches out to you proclaiming:

I am the way, and I will bring you safely home if you will heed my warning. I will give you comfort, instead of fear. My light will give you protection. You can depend on me to reveal the hidden disasters that would be lurking in the cover of darkness. I stand on a good foundation of promise and confidence. My light continuously sweeps the waters, whether they be rough or calm. I have stood the test of time; I will stand watch for you. You depend on me to be faithful and give you guidance. I must depend on the care of the keepers to check and recheck, and check again, to make sure that I am in good order. I must keep my light burning so I can provide you with safety and protection.

If we could only see what the lighthouse has witnessed through time: the sparkle of the sun glistening over the waters, a gorgeous sunset, a ship's silhouette against the horizon as day gives way to the night, a spectacular sunrise, the landscape covered in a blanket of snow, or the laughter of children playing barefoot along the shore. We like to see tranquillity in time, but there is more to life. There are dangers and turbulent waters all around.

Darkness is the absence of comfort. It holds a fear of danger and uncertainty. This is why the first glimpse of a lighthouse holds so much power. She stands so faithfully, sending out her beam to chase away the darkness. She gives those in search of her light a joy of relief and peace in hope.

Keepers Dykeman, Martin, and Armstrong have left us a treasury of views capturing their everyday life—a legacy and a moment from a time when the water was a highway of vessels and activity. They have frozen time for us so we can inspect, learn, and gain a better understanding of how these people lived and worked along the shores of Lake Michigan nearly a century ago.

This book is not intended to be a complete history of the Michigan City Lighthouse but a narrative of the three keepers from 1904 through 1920. Through their numerous photographs and First Assistant Thomas E. Martin's journals, we see the events they recorded that touched their lives during this period. For example, Tom's journal records for us his day on May 27, 1920: "N.W. to N.E. Mod. Cloudy. Painted the breakwater lantern, polished the lens and brass, painted the west pier railing and deck and polished the lens and brass, scrubbed the boat and dusted, mopped the floor, polished the brass." This gives us a glimpse of what a keeper's day was like in the U.S. Lighthouse service. Although many of us see the romantic charm surrounding the lighthouse service, there was also the reality of hard work maintaining a government facility. To these men, the lighthouse was home.

For me, this was a magical place to visit, and I thoroughly enjoyed the time I spent at the Michigan City Lighthouse putting this pictorial history together.

One
THOMAS J. ARMSTRONG

It was 1904, and the country was again ready to re-elect former "Rough Rider" Teddy Roosevelt to another four-year term in the White House. The Panama Canal was underway, and the nation was growing, opening opportunities for those who would dare to dream and turn their hard work into reality. For Thomas J. Armstrong, 1904 brought a new position as head keeper of the Michigan City Light Station after leaving Wisconsin's Pilot Island Light.

A chill was in the air, and an umbrella of color covered the lakeshore as he reported to the newly remodeled lighthouse residence on October 14. The construction on the north end of the lighthouse was now completed, as the workers had just finished the brickwork and removed the scaffolding. The light tower had been taken down and a second chimney added. The former lighthouse had now become the keeper's dwelling, with a two-family unit entirely separate.

Six days after Tom began his duties, laborers carefully moved the fifth order Fresnel lens out to the new structure on the east pier. The light would guide mariners until its relocation to the Michigan City Lighthouse Museum in 1980, where it is still on display today.

It was a wonderful time for Thomas Armstrong to appear on the scene with all these landmark events taking place. Not only were there changes in the lighthouse station, but also the changing of personnel was important.

Tom Armstrong relieved the colorful light keeper Harriet A. Colfax, the third woman to serve the light station. Upon her resignation from the service, she had compiled a 43-year career in Michigan City. She left behind a legacy of tradition for many young light keepers to follow, and a deep pride in the uniform they wore.

Thomas settled into the new keeper's residence with his family: wife Jessie, and daughters Sylvia and Amber. Six months later, on April 1, 1905, the Lighthouse Board saw fit to send First Assistant George H. Sheridan to help Tom in his many duties at the light. George had grown up at the South Manitou Light, the son of Aaron and Julia Sheridan, and later had served at the same beacon.

Keeper Armstrong's home was the car ferry port of Frankfort in northern lower Michigan. Whenever the opportunity arose, he would take leave from service and visit, rekindling old friendships and family ties.

Thomas Armstrong served as keeper of Michigan City Light until September 1, 1919, when he was transferred to the Chicago Harbor Light. He was replaced by Philip Sheridan.

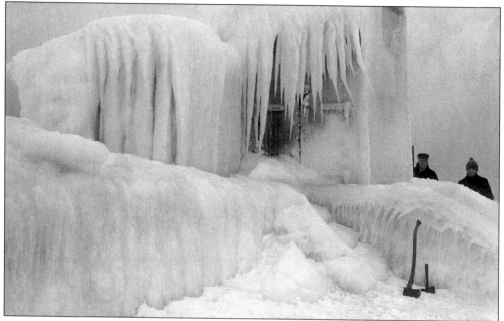

Pictured here is the west pier breakwater light covered in ice. Thomas Armstrong, on the left, and Fred Dykeman, on the right, are looking over the situation before they chop the ice away from the access door.

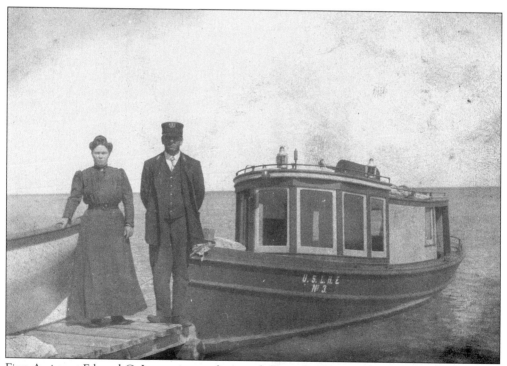

First Assistant Edward C. Lettan is seen here with his wife. He served as second assistant from 1907–1909 in Michigan City under Thomas Armstrong. Notice the lighthouse launch with the bow letters, U.S. L.H.E. No. 3, which stands for United States Lighthouse Establishment.

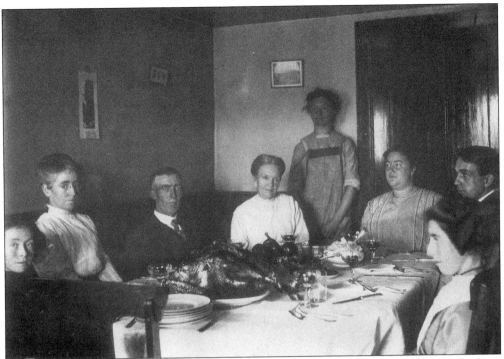

Thanksgiving dinner is about to begin at the Michigan City Lighthouse. This photo was taken in the lower portion of the house, where they ate. Seated from left to right are: Amber Armstrong, Jessie Armstrong, Thomas Armstrong, Jessie's mother Lottie Martin, Thomas Martin, and Sylvia Armstrong.

Head Keeper Thomas Armstrong poses with his family. From left to right are: daughter Amber, Thomas, Jessie's mother, wife Jessie, and daughter Sylvia.

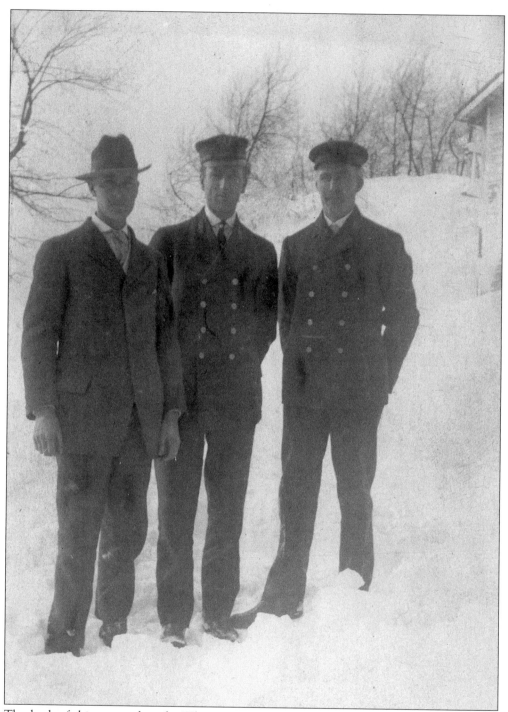

The back of this postcard reads: "This is a picture we had taken Sunday with Ed's camera. Captain and I and Ed's friend from Whitehall." Head Keeper Tom Armstrong is on the right, and Fred is in the center. The "Ed" mentioned here is Edward Lettan, who served as second assistant from June 1907 until May 1909, when he was promoted. Ed left the light in March of 1911, when Tom Martin came aboard.

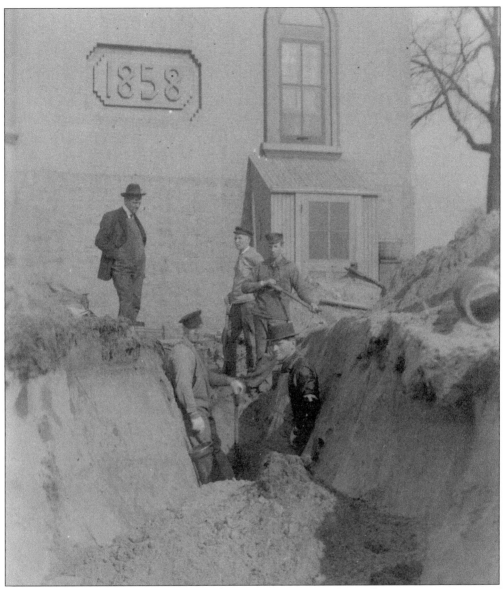

Work was done on the south end of the lighthouse residence in 1910, with the laying of drainpipe. Second Assistant Fred Dykeman is on the far right with a shovel, and Keeper Thomas Armstrong is next to him. The back of this card read:

Dear Anna,
March 11, 1910

I will send you a picture of our work and suppose you can find me on it if you look closely. We are thinking of opening up Monday at the signal and then we can take our nice times out there and listen to the sea's and pounding again.

Fred Dykeman
2nd Asst. Lightkeeper

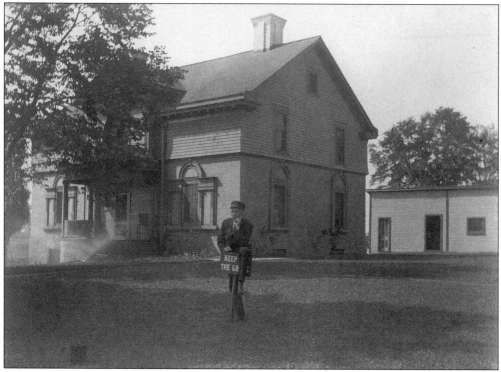

Head Keeper Thomas Armstrong leans on the "keep off the grass" sign. The lighthouse residence is in the background.

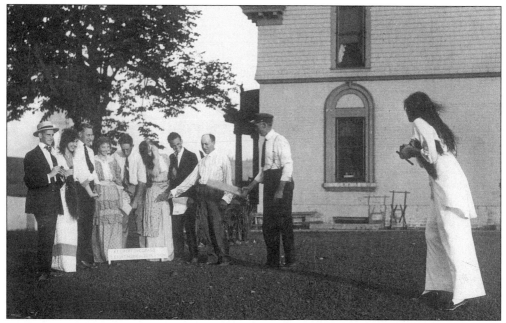

A group visits the lighthouse residence and has fun with the sign at their feet: "Keep off the grass. U.S. Lighthouse Reservation." The keeper with the board in hand is Head Keeper Thomas Armstrong. The girl on the far right is about to take a photo of the group with a box camera.

14

Two

FRED DYKEMAN

It was on a warm July day in 1909, when Alfred Dykeman arrived in Michigan City. Walking down through town, he was aware of the many flags and red, white, and blue bunting still hanging outside buildings—a reminder of the Independence Day celebrations the day before. With his few belongings in hand, he walked down the pathway leading to the lighthouse. Here he reported for duty as the second assistant keeper of the Michigan City Light Station. In time, Fred became a close friend to Head Keeper Thomas Armstrong, who the assistants called "Captain" or "Keeper." He guided Fred through the everyday duties and the many chores that come with the operation of a Spartan lighthouse.

Fred began a courtship with Anna Haan of Grand Rapids, Michigan, and corresponded with her almost daily, explaining the everyday life at the light. Here is a card from March 26, 1910:

> Dear Anna,
> I will drop you this card as I mailed you a letter this afternoon and will drop you this card after supper as we will open up tomorrow night. I have the first watch, I will have to light up. I will start the signal at sundown, will have watch from 7 p.m. to 1 a.m.
> Fred Dykeman

Keeper Dykeman continued to live year-round at the station until March 1912, when he and Anna were wed. After his marriage, the couple lived at the light station from March through October. They spent the winter months in Grand Rapids, Michigan. Those keepers that stayed the winter kept the ice buildup off the access doors and worked to prevent any ice damage to the pier lights and walkways. For this work in 1917, they were paid $2.25 a day. The average wage in the 1900s was 19¢ an hour, compared to $13.40 in the 1990s.

Fred and Tom kept up correspondence during the time Fred was away, keeping him updated on the events at the light and area happenings. March brought Fred back to the light to open it up with the other keepers. He would send for Anna a few weeks later.

The couple continued this yearly arrangement through the 1915 season, when Fred decided to resign from the service and return back to Grand Rapids. Work was hard to find for Fred, and the keepers kidded him about returning to the service.

Fred did find work as head custodian at Widdicomb Grade School on the west side of Grand Rapids. Later, he became groundskeeper at Houseman Athletic Field. At the age of six, my Aunt Loie remembers passing Fred, as he would sit on his porch stairs. She would stop and coax him out of 5¢ for an ice cream cone. Fred and Anna never had children, but he is remembered for his love for the neighborhood children.

On July 1, 1916, Howard A. Kimble was assigned to the Michigan City Light Station to replace Fred as second assistant keeper.

Fred Dykeman and Anna Haan posed for a wedding picture on March 12, 1912. Anna and Fred were from Grand Rapids, Michigan, and when Fred resigned in 1916, they returned to live there.

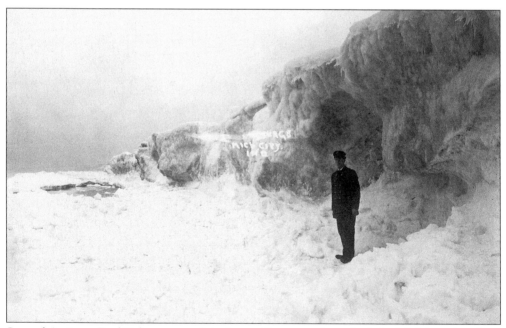

Second Assistant Fred Dykeman stands in front of ice caves along the Lake Michigan shoreline. Tom Martin took this picture. In his journal he wrote: "Came off watch at 7. After breakfast I went up to see Clara and the baby. After dinner, Harry Ohming and I went down on the east beach to take pictures."

16

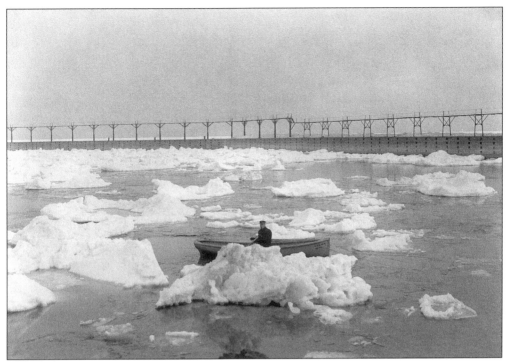

Second Assistant Keeper Fred Dykeman is seen in the lighthouse dinghy in January. (Note on the bow of the boat the letters U.S. L.H.S. No. 40).

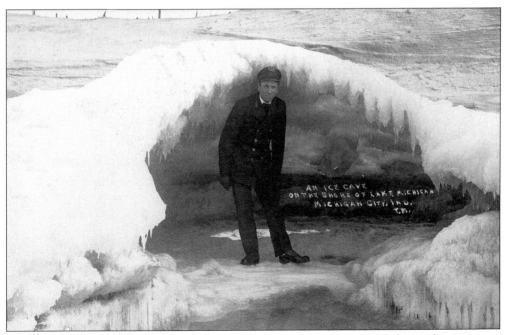

Second Assistant Fred Dykeman stands in an ice cave along the Lake Michigan shore.

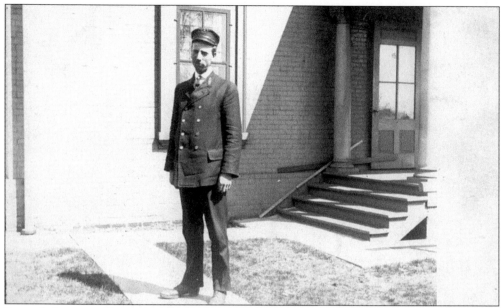

Second Assistant Keeper Fred Dykeman poses in front of the Michigan City Lighthouse Residence. Fred wrote Anna on March 27, 1910, as follows: "I rec'd your letter today and glad to hear from you and will answer it at the signal early Monday morning as I go on watch at 1 o'clock and stay on till seven Monday morning. We worked all afternoon filling the boiler, getting the light ready."

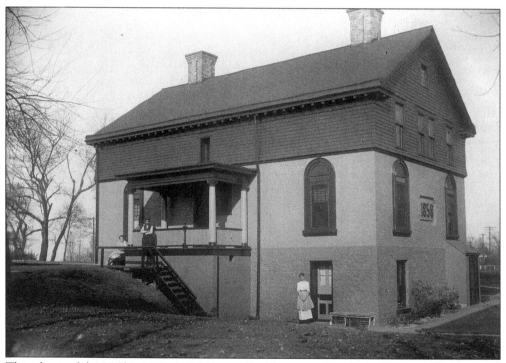

This photo of the Michigan City Lighthouse Residence is taken from the west side. Standing near the door on the lower level is Anna Dykeman. Above are Lottie and Tom Martin.

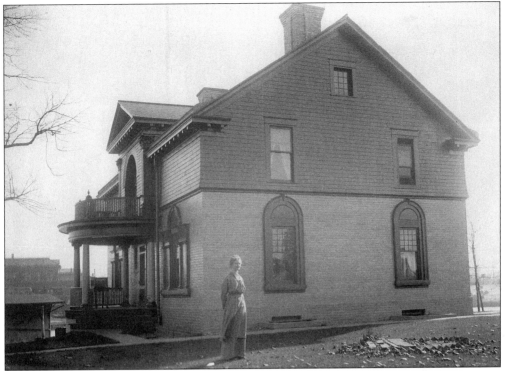

Anna Dykeman stands on the north side of the Michigan City Lighthouse residence.

Shown here is the back of the lighthouse residence at the lower level. From left to right are: Second Assistant Fred Dykeman, Amber Armstrong, Anna Dykeman, and Sylvia Armstrong.

Photographed here is a gathering with Anna Dykeman, standing in the back row, third from the left. Fred Dykeman is seventh from the left in his uniform. Jessie Armstrong is next to Anna, and Lottie Martin is second to the right of Jessie.

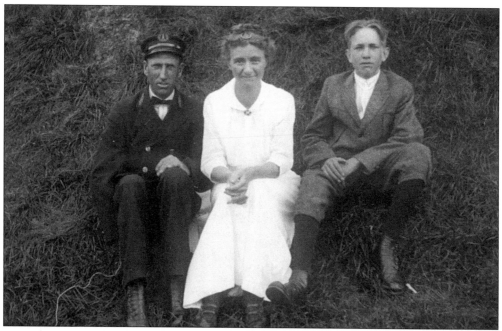

Second Assistant Keeper Fred Dykeman and Mrs. Fred Dykeman pose with an unidentified man, possibly Cecil Martin, First Assistant Thomas Martin's son.

Second Assistant Keeper Fred Dykeman poses in front of the Michigan City Lighthouse Residence. He served at Michigan City Light from 1909–1916.

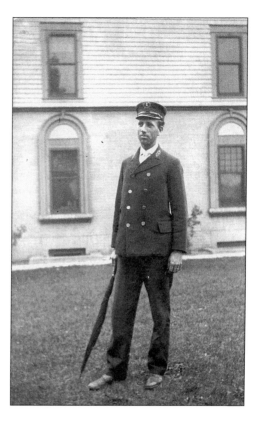

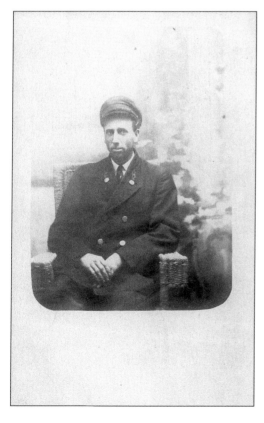

Second Assistant Keeper Fred Dykeman is pictured here. The Michigan City Lighthouse was the only light at which Fred served.

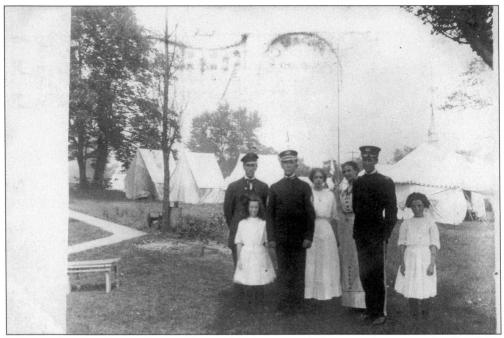

An army bivouac was set up near the Michigan City Lighthouse in August 1912. The photo could have been taken in Washington Park. Second Assistant Keeper Fred Dykeman is on the left. Keeper Thomas Armstrong's daughter, Amber, is in front of Fred. His daughter, Sylvia, is on the far right. Fred's wife, Anna, is standing in the back on the right.

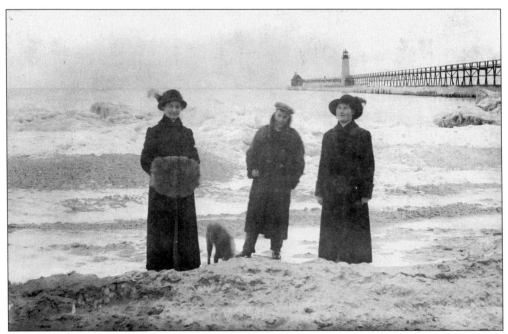

Here Anna Haan, on the left, poses with some of her relatives as they visit the Grand Haven shoreline during the winter. The Grand Haven South Pier Lights reach out into Lake Michigan in the background.

Three

THOMAS MARTIN

The third keeper to make up this group was First Assistant Thomas Martin, who reported for duty on May 1, 1911. Tom was no stranger to the duties of a light keeper. He had just spent three years on Poverty Island, located at the approach to Green Bay from Lake Michigan. Here he had operated the 70-foot-high beacon for mariners on the somewhat isolated station. One can only imagine the reaction of Tom's family when they got the news that they were leaving the island and being transferred to the Michigan City station.

Thomas was born on March 25, 1881, in Hingham, Wisconsin. He married Charlotte Schuber on his birthday in 1899, in Sheboygan, Wisconsin. The couple had one child, a son named Cecil.

Tom, Lottie, and their son settled into the new station and became a part of the community they served. Tom's friends said that he always had a smile and a friendly greeting for all those he met. Thomas Armstrong, Fred, and Tom became very close friends and worked well together operating the light station.

Tom Martin left a wonderful legacy to the Michigan City Lighthouse Museum in the many journals he kept. Daily events were written down in detail, giving the reader a glimpse into the life at the station and those he came in contact with.

Light Keeper Martin served at the Michigan City Light the longest of the three keepers. He ended a 23-year stay with his death in June of 1934, while still in service.

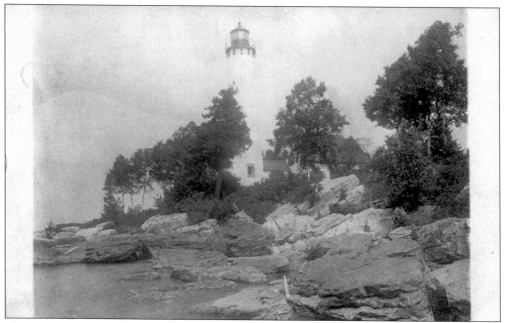

This is Poverty Island Light, where Tom and Lottie Martin served for three years. The light was built in 1874–75, and guided vessels into Green Bay. Tom took the photo while stationed there.

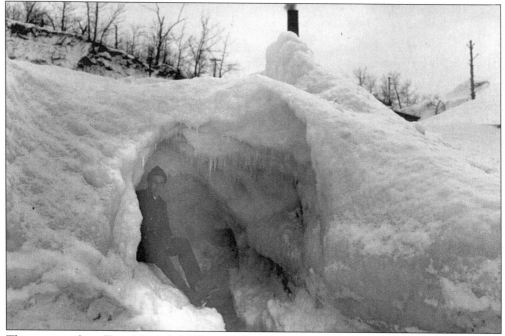

This excerpt from Tom Martin's 1920 journal read: "January 11, W. Mod. Clear. Clara, Lottie and I took a walk along the ice banks on the W. beach, I took three views of the banks. No open water." This photo is of Tom Martin in an ice cave along the beach.

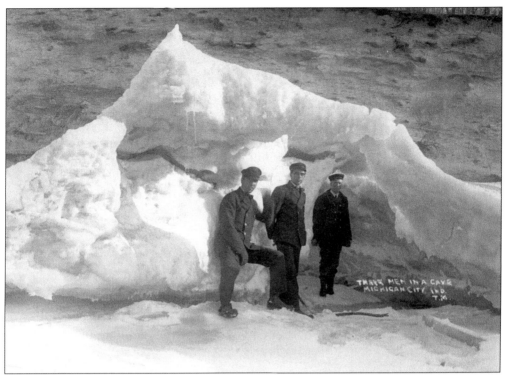

Posing in front of an ice cave along the Lake Michigan shore are, from left to right: Second Assistant Keeper Fred Dykeman, First Assistant Thomas Martin, and an unidentified man.

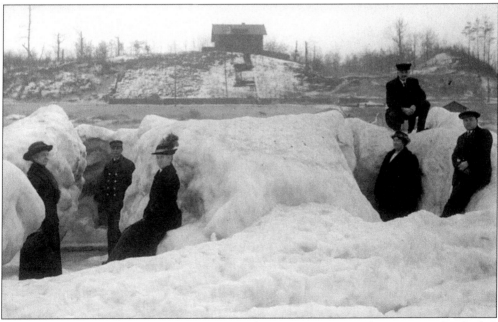

Perhaps this is a Sunday afternoon outing, and the group is enjoying the ice caves. On the left are Thomas Martin and Mrs. Thomas Armstrong. On the right is Lottie Martin.

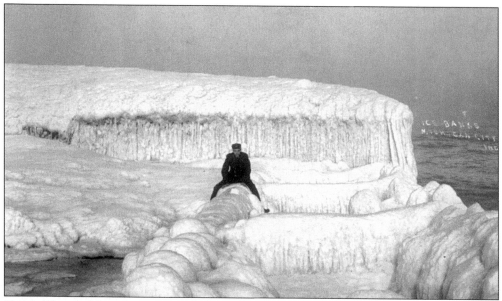

Keeper Thomas Martin sits on top of ice banks along the channel. The back of this card, dated January 29, 1914, from Tom Martin to Fred, reads: "Been having some lovely weather here. At 11:00 a.m. today it was 5 degrees above and at 1:00 p.m. 32 degrees. Everything here is all ok. Tom and I have taken quite a few good views, have not done much else since you left."

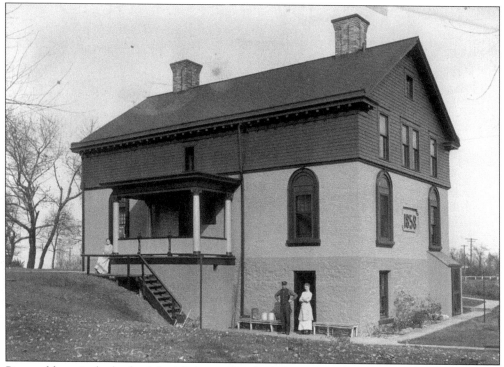

Pictured here is the back of the Michigan City Lighthouse Residence. Lottie Martin is on the upper left, and Fred and Anna Dykeman are on the lower right. The foundation of the building was made of Joliet stone, and the superstructure was made of Milwaukee brick.

In the center of this photograph is First Assistant Keeper Thomas Martin. On each side of Tom are Mr. and Mrs. Howard A. Kimble. Howard was a former second assistant keeper at Michigan City. On the far left is Howard's brother from Frankfort, and Lottie Martin is on the far right.

Lottie Martin poses for a portrait. She spent her entire marriage to Tom Martin serving at various lighthouses on the Great Lakes.

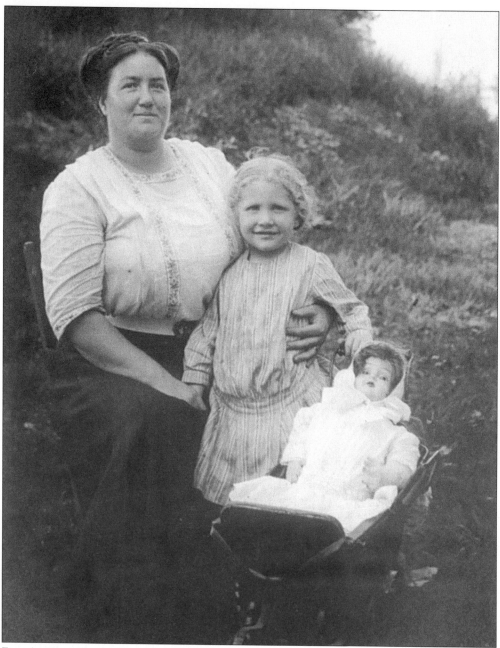

First Assistant Keeper Tom Martin's wife, Lottie, is pictured here with an unidentified little girl and her doll. In Tom's journal, dated May 21, 1920, he wrote: "S. to S.E. Light, Clear. Painted the E. and W. sides of the signal. Lottie left today for a week's visit in Hammond and Chicago." On November 2, he wrote: "Bought a bench wringer for Lottie, I put on new legs so as to make it higher." The December 28 entry reads: "Helped Lottie with the wash!"

The life of a keeper's wife was hard, and many journal entries tell of her periods of illness and the long recovery time following a bout of sickness. However, there were some advantages for her. Being close to a large city meant having many friends and attending social events. Stores were readily available, and medical care was only a step away.

First Assistant Keeper Thomas Martin, above, served at the Michigan City Light from 1911 until his death in 1934. Today, when you visit the Michigan City Lighthouse Museum, you can see the daily journals kept by Martin in a display case. Without his daily logs, many wonderful events of the lighthouse keeper's life would have been lost in time.

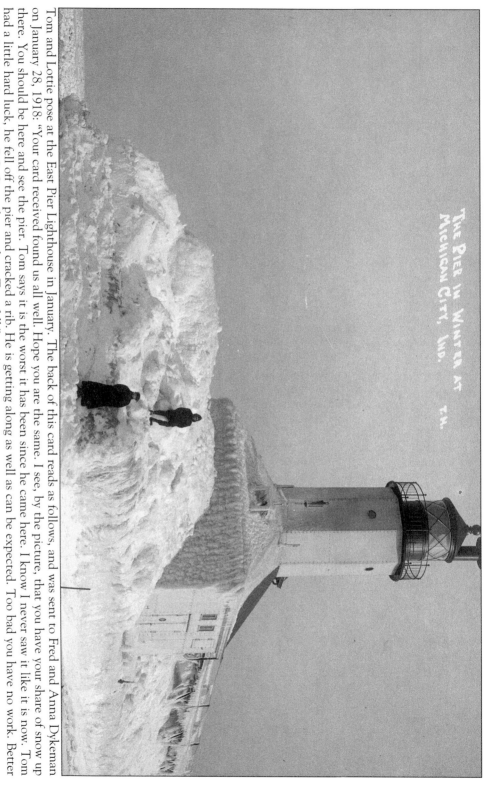

THE PIER IN WINTER AT
MICHIGAN CITY, IND.
T.M.

Tom and Lottie pose at the East Pier Lighthouse in January. The back of this card reads as follows, and was sent to Fred and Anna Dykeman on January 28, 1918: "Your card received found us all well. Hope you are the same. I see, by the picture, that you have your share of snow up there. You should be here and see the pier. Tom says it is the worst it has been since he came here. I know I never saw it like it is now. Tom had a little hard luck, he fell off the pier and cracked a rib. He is getting along as well as can be expected. Too bad you have no work. Better come back in the service. P.S. Cross shows where Tom fell."

30

Four

LIGHTHOUSE TENDERS

As lighthouse stations continued to be built across the country, a real need arose for vessels to supply this network, especially the many remote stations on islands and isolated peninsulas. At first the Lighthouse Board decided to charter schooners for supplying these lights. Later they changed over to all steam-powered propellers. In 1857, the decision was made to purchase and operate the service's own fleet of supply tenders.

The tenders who serviced Lake Michigan were stationed at the Ninth District Lighthouse Depot in St. Joseph, Michigan. This terminal played an important role as a storehouse for replenishing the light stations with supplies, fuel, and needed repairs to the stations.

The lighthouse keepers always kept a wary eye on the horizon for the first glimpse of the tender, as they knew the inspector would be on board, and their station best be in order.

The tenders *Sumac* and *Hyacinth* were the most frequent visitors to the Michigan City Light Station. These tenders were named after flowers, trees, and plants.

The tender, *Sumac*, was built in 1904, in Port Richmond, New York. She weighed 700 gross tons, and was powered by a 700-horsepower engine. The screw-driven steamer was 168 feet long, 30 feet wide, and had a depth of 14.1 feet. The steamer became surplus after World War II, and was sold to the Commerce Lines to be converted to a package freighter in 1945. This never happened, and the old tender laid in Sturgeon Bay until it was scrapped in 1957.

The journals of First Assistant Keeper Thomas Martin have several entries regarding these tenders servicing the light at Michigan City. These entries are as follows:

March 2, 1922—N.E. Mod. Clear. Painted the S-W and part of the N. side of signal, the Sumac *came in at 5 p.m. and Captains. Hubbard and Trout inspected the station.*

March 3, 1922—N. Mod. Clear to clouds. The Sumac *left for St. Joe at 4 a.m. We unpacked the supplies. The laborers and I went out and tested the gas and finished painting the N. end of the signal. Cleaned up the shed and sprinkled lawn.*

September 13, 1920—E. to N.E. to S.E. light, cloudy. Came off watch at 7. The Hyacinth *came*
i in at 2:30 and delivered 13 gross tons of coal at the signal, left for St. Joe at 5:45.

In August 1914, Keeper Thomas Armstrong was shipped onboard the lighthouse tender, *Sumac*, until the end of September when he returned to his regular duties at the Michigan City Lighthouse. Tom wrote back to the station and took photos of the various lights they serviced along the western Lake Michigan shore.

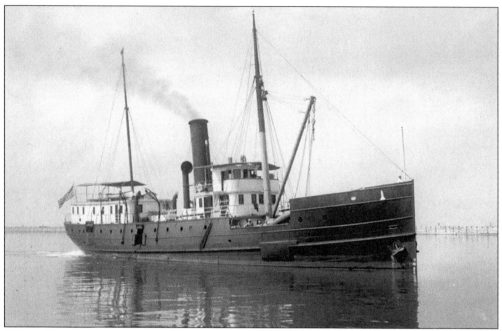

Pictured here is the lighthouse tender *Sumac* entering Michigan City. There were over 230 tenders that existed, served, and then disappeared. Today only two still exist, and they are in danger of being scrapped. Note the lighthouse insignia on the bow.

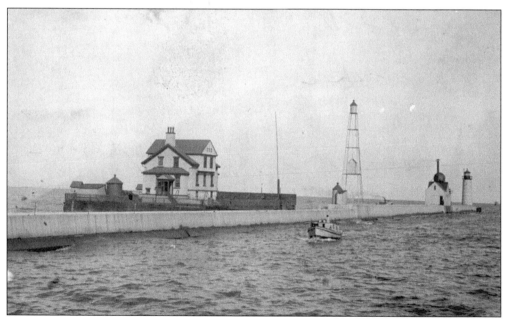

The Milwaukee Pierhead Light, in the above photograph, was built in 1906. From Milwaukee, Tom wrote back to Fred:

> *We are still at the coal dock here, will take all day Thursday to finish coaling up. Will probably leave here sometime Friday and will probably get to Michigan City about the 20th but will let you know. I am glad you don't get much fog.*

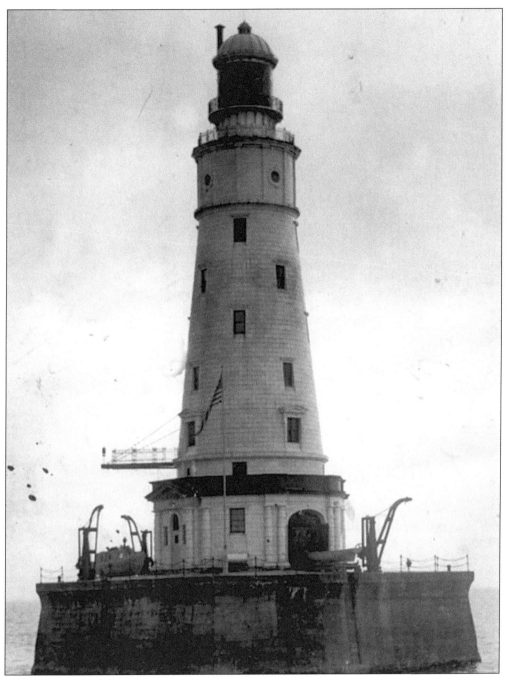

The above photo is of the White Shoal Light. Today, this light is painted like a red barber pole. White Shoal Light is located 20 miles west of Old Mackinac Point, on the northern top of Lake Michigan. A lightship was stationed there in 1891, until the lighthouse was completed in 1910.

On August 25, 1914, Tom sent the above postcard photo which he took of the then four-year old White Shoal Lighthouse with the following message: "Just arrived. This is a view of White Shoal Light Station taken when it was raining. I got a dandy picture of it today with the big camera."

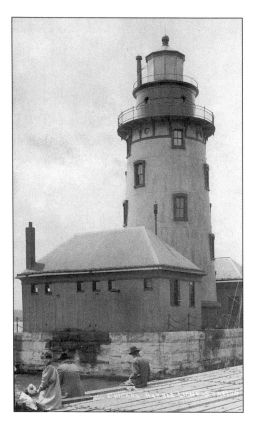

Armstrong took this photo of the Chicago Harbor Light when he was assigned to the tender *Sumac*. This light was built in 1893. This photo was taken before the entire lighthouse was moved from the mainland to the south end of the northern arm of the outer break wall. The work was done in 1918–19.

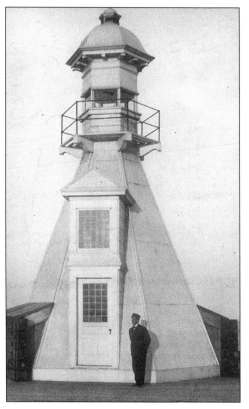

The Racine North Breakwater Light and its keeper pose at the right. The light was built in 1903. The back of this postcard reads: "Well, we are getting some nearer to M.C. and will no doubt be there about the 21st, if everything goes all right. We have been hung up at Racine for several days, too much sea, and it was for nearly a day."

34

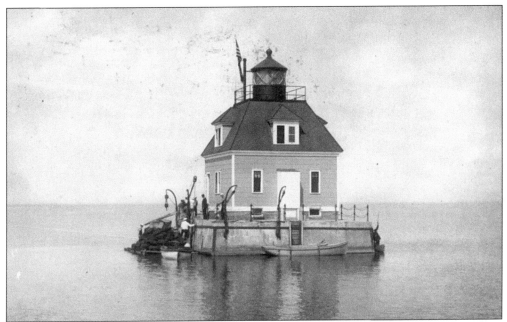

This lighthouse is the third and last Long Tail Point Lighthouse, which became known as the "Tail Point Light." It was abandoned in the 1940s. A storm in 1973 washed the deserted light away.

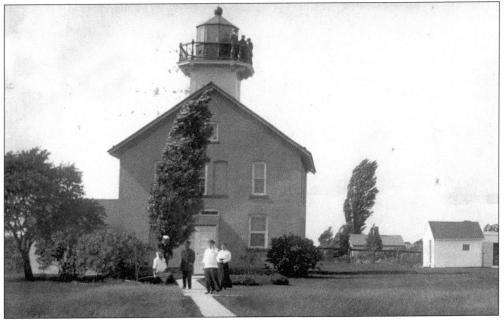

This is Green Island Light Station, built in 1863. The island was a remote station to serve on, being only 4 miles off the coast of Marinette, Wisconsin. On the left are the First Assistant George W. Drew and an officer from the *Sumac*.

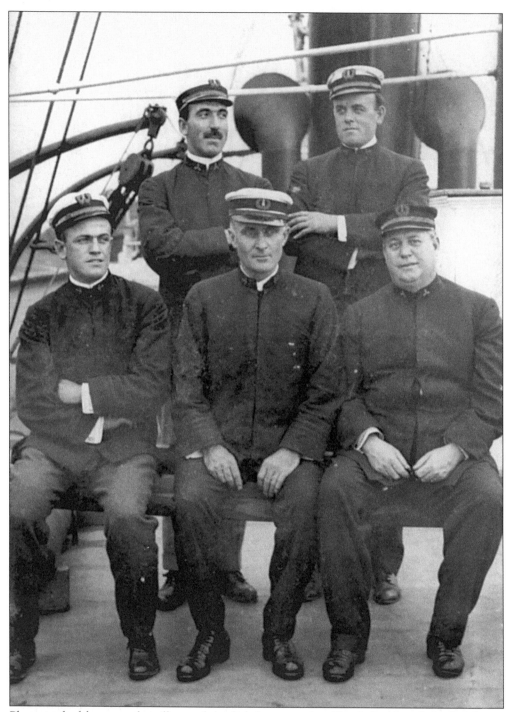

Photographed here are the officers of the lighthouse tender, *Hyacinth*. Aboard the lighthouse tender, *Sumac*, Thomas Armstrong writes: "I just received your letter and glad to hear from you. We are coaling up today, will deliver coal and supplies. I will take pictures and probably leave here September 2nd. It rained to beat the band here last night. Going down the bay to Plum and Pilot Island, Cana Island and up the shore, providing things don't change and go back to the **soo**."

The lighthouse tender, *Hyacinth*, replaces part of the fog-signal. Note the lighthouse flag flying from the tender's mast and the children sitting on the pier fishing in the foreground.

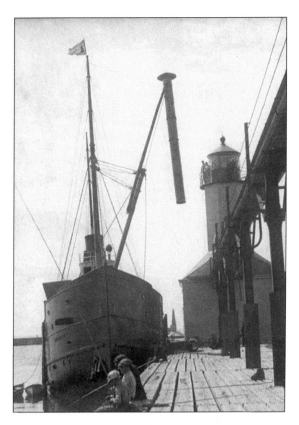

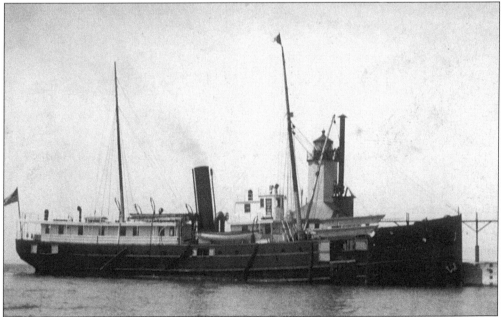

Lighthouse tender, *Hyacinth*, installs a new fog signal for the East Pier Lighthouse in Michigan City, Indiana. Keeper Fred Dykeman hiked to the west pier to snap this side view of the *Hyacinth*.

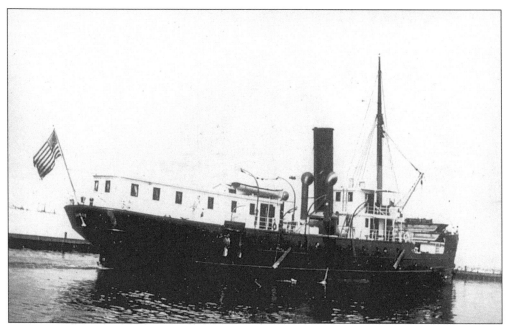

Thomas Martin's journal entry from August, 1920, reads: "Aug. 11—S.E. to E. Light, Clear. Polished the brass on No. 1 boiler, automatic and lubricator, steam pump and whistle, washed the plate glass port lights and windows, *Sumac* came in at 7:30 p.m. captain Hubbard was aboard."

"Aug. 12— Light variable winds, Cloudy. Captain Hubbard inspected the station today."

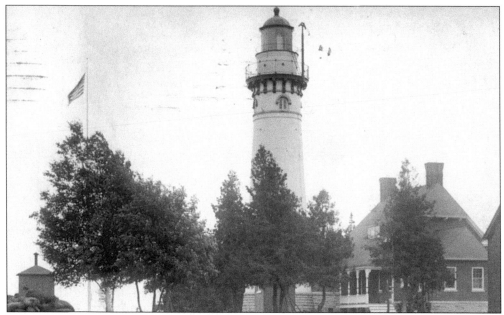

The Seul Choix Point Light was completed in 1895, at the cost of $18,500. It is located on the south shore of Michigan's Upper Peninsula, 60 miles west of the Straits of Mackinac.

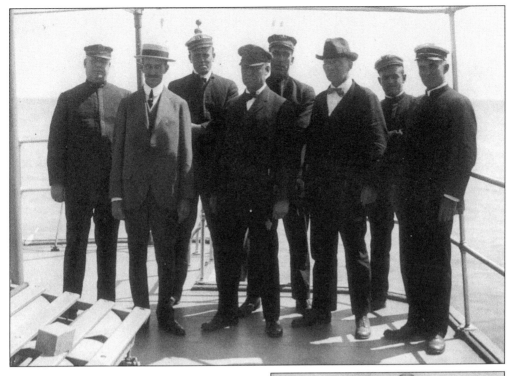

This photograph was taken on board the lighthouse tender, *Hyacinth*, in Michigan City. Six of these men are the officers of the tender accompanied by two lighthouse inspectors. These tenders were kept busy supplying the many light stations, as Tom's letter below shows.

Well, we have left Twin River Point Station, 7:30 p.m. Make Manitou Island tonight. But have got to come back to finish coaling up. To be in Milwaukee Sunday. Will be there about 2 or 3 days.

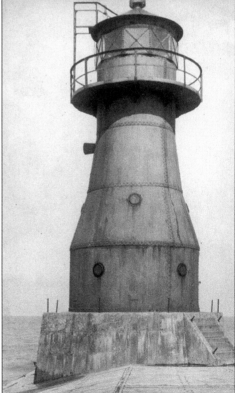

Built in 1911, this red steel light is located on the end of the breakwater in Gary, Indiana.

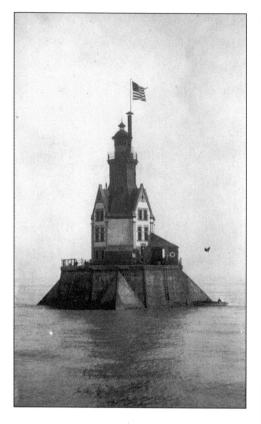

The Racine Reef Lighthouse stayed in operation until 1954. The Coast Guard tore it down in 1961. Notice the small boat on the lower right with two keepers in it.

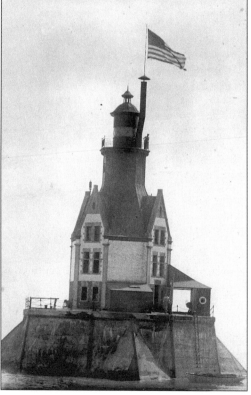

The Racine Reef Light was photographed by Keeper Armstrong from the tender, *Sumac*. This light was built in 1906, 2 miles off shore from Racine, Wisconsin. Notice the keeper on the right leaning on the railing below the flag.

Five

THE SHIPS

The wind was howling down Lake Michigan, making it hard for Fred Dykeman to keep his hat on. It was 1909, and Fred had only been at the Michigan City Light Station for a couple of months. Pulling his white jacket on, he headed for the East Pier Light and the beginning of his 7 a.m. watch. Along with him this blustery day were two government inspectors going out to inspect the catwalk and condition of the piers.

It was an adventurous walk out to the light signal, as the waves occasionally broke up onto the catwalk. Shortly after their inspection, the two men went back to shore, and Fred continued his duties in the light signal.

As Fred peered out the tower window, he spotted the three-year-old steamer, *Theodore Roosevelt*, coming in off the lake. Fred had his camera with him this watch, so he positioned himself to take a photograph. Through the lens he saw the bow raise up out of the swells and then fall back down, waves exploding from her stem. Smoke was being blown from her twin stacks off in streams by the strong north wind. Satisfied with this shot, Fred set his camera aside and continued his watch.

As in this photo of the *Roosevelt* taken by Fred, and others by Tom Martin and Thomas Armstrong, these mighty ships are captured for us. This was a time when the port of Michigan City was at the height of her maritime glory.

The following pages will show the images of passenger boats bringing in loads of vacationers from Chicago, Milwaukee, and the western shore of Lake Michigan. The excursionist enjoyed all-day company picnics as they disembarked from the many different vessels.

The harbor was also a busy place for the many family-owned fishing tugs. These leathery-faced locals working their tugs have been recorded by the keepers. All year long, through ice-choked harbors and large rolling swells, they went out to their fishing grounds to drop their nets.

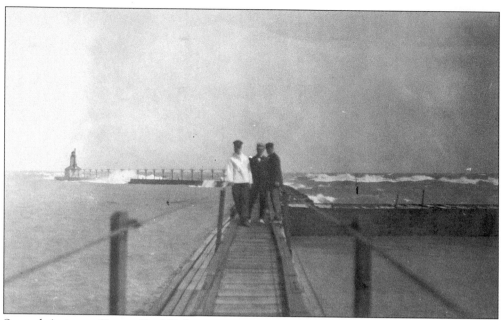

Second Assistant Keeper Fred Dykeman is seen with two government pier inspectors. This photo was taken from the catwalk during a rough day. On the back of this postcard, Fred tells Anna to "look closely and you can see the lighthouse wreath on my cap."

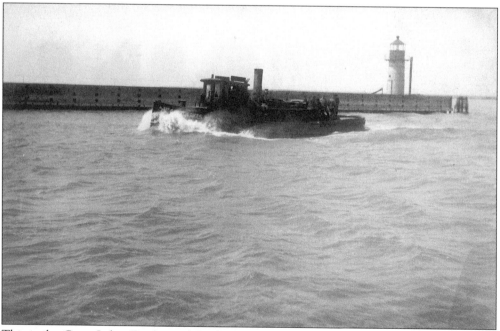

This is the Great Lakes Dredge and Dock Company's tug, *Alert*, passing the West Inner Pier Light. This small tug was built in Chicago, Illinois, in 1874. The *Alert* had a length of 49 feet, width of 13 feet, and was 6 feet deep. She operated out of Chicago, Illinois, with a five-man crew.

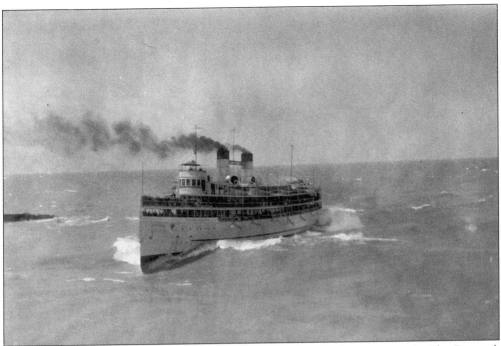

The above photo was taken form the East Pier Light when Fred was on watch. The *Roosevelt* rocks and rolls as the steamer pushes the heavy swells aside entering Michigan City.

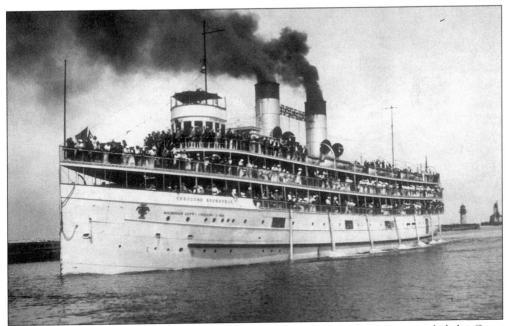

Pictured here is the *Theodore Roosevelt* entering Michigan City. The steamer sailed the Great Lakes for 44 years and was finally scrapped in Milwaukee, Wisconsin, in 1950.

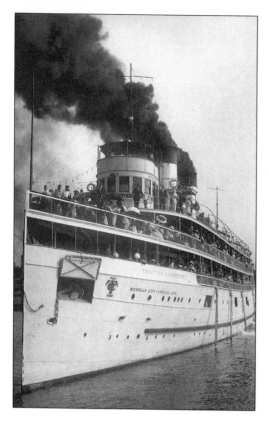

On a busy day, the *Roosevelt* pulls away from the dock—a far cry from this note that Tom Martin sent to Fred on July 8, 1917: "Well, I did not get to Grand Haven last week, will try and manage it the week of the 22nd. Things are dead here this summer, some days the *Roosevelt* only has 50 people and at no time does she have a good crowd, not even Sundays."

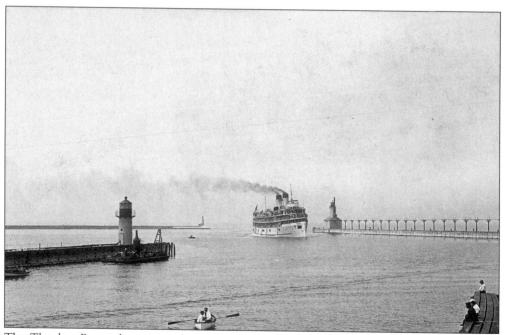

The *Theodore Roosevelt* is pictured entering the harbor at Michigan City on a calm summer's day. Note the barge with a donkey engine alongside the west inner pier wall on the left.

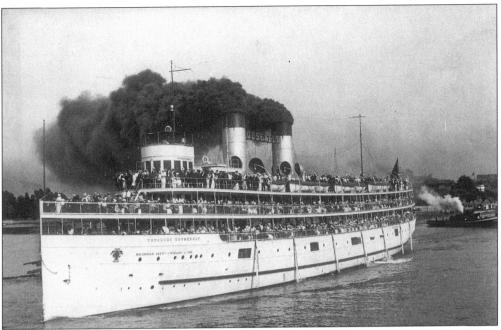

Docking in Michigan City was the steamer named after the 26th president of the United States, Theodore Roosevelt.

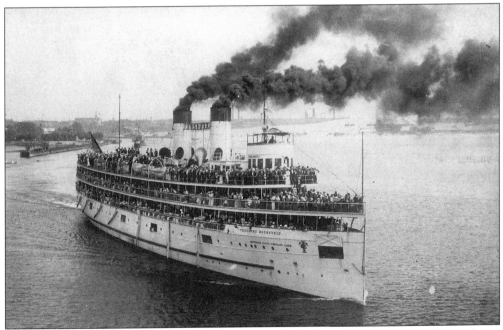

The steamer heads out of Michigan City, her bow pointed toward Chicago. The *Roosevelt* was built in 1906, in the Toledo Shipbuilding yard, as hull No. 107. She had overall dimensions of 289 feet by 40 feet, by 23 feet, 4 inches.

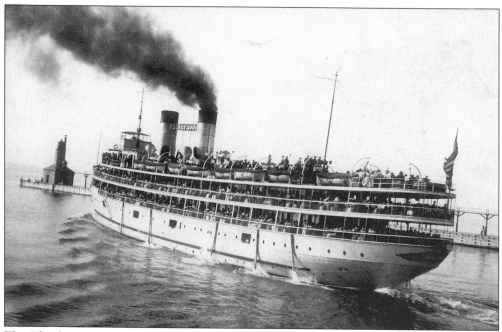

The *Theodore Roosevelt* left Michigan City with excursionists. The vessel had a capacity for 3,500 people.

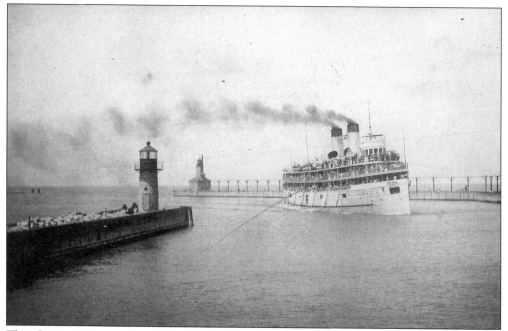

The day-excursion steel passenger ship, *Theodore Roosevelt*, enters the inner channel at Michigan City. Her regular schedule included two round trips daily between Chicago, Illinois, and Michigan City, Indiana. When the United States entered World War I, the steamer was used as an officer's training ship for the U.S. Navy through 1918.

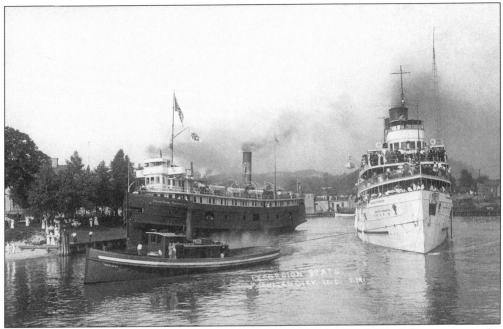

This was a busy day in the port of Michigan City, with the tug *J.W. Callister* towing the *Theodore Roosevelt* around the *Kansas*. The ships are discharging their passengers at the Indiana Transportation's dock on the north bank of Trail Creek, west of Franklin Street Bridge. By landing here, the vacationers had easy access to Washington Park.

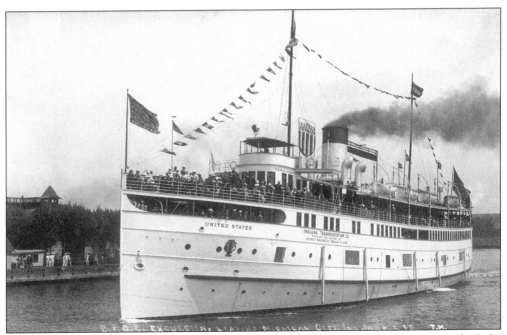

The steamer *United States* heads out of Michigan City with a group of excursionists. The Life-Saving Station is on the left. The vessel sailed on its maiden trip May 20, 1909, from the yards in Manitowoc, Wisconsin, to Chicago, Illinois, to inaugurate the new service.

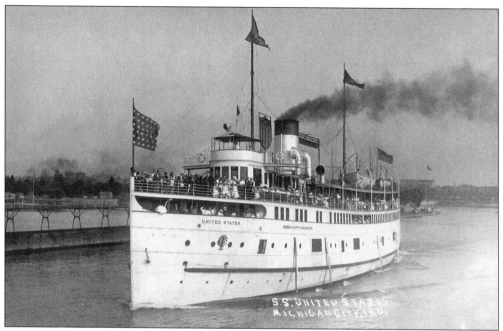

The *United States* heads out from Michigan City. The forward part of her main deck was taken up by a cargo hold for various freight cargoes.

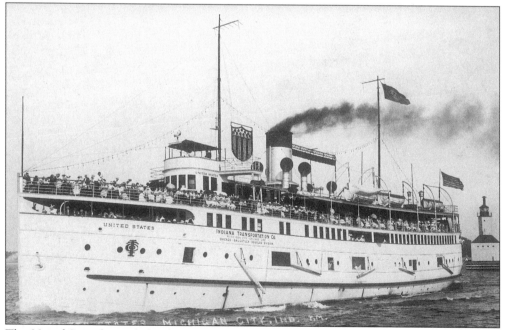

The *United States* leaves behind Michigan City, as the steamer heads out into Lake Michigan. The main salon was located in the center of the staterooms. On the promenade deck, there were mahogany-lined cabins which ran the full length of the steamer.

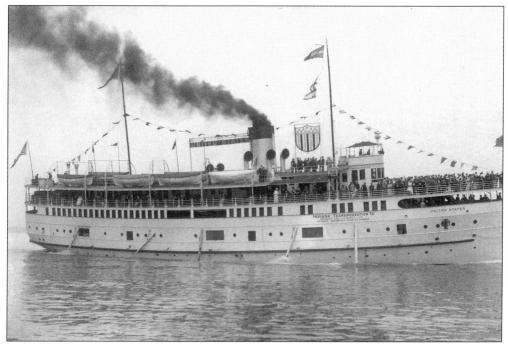

In 1916, the *United States* was chartered to the Crosby Transportation Company, and shortly after sold to them.

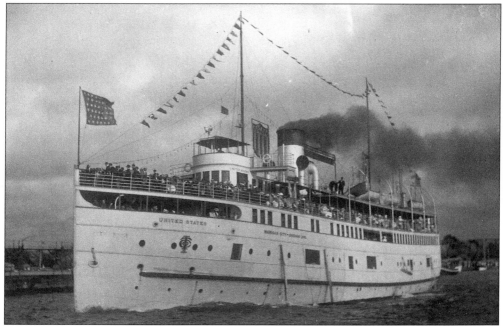

The *United States'* route changed under the Crosby banner. She sailed into the ports of Grand Haven, Muskegon, and across to Milwaukee. At the end of the 1916 season, she was sold off-lakes.

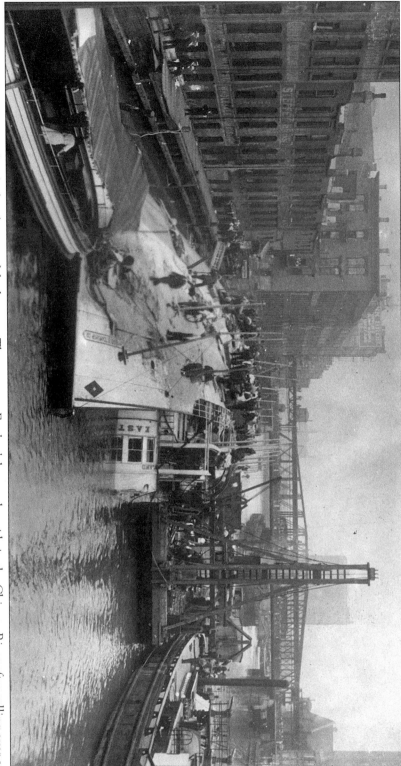

This is a real photo postcard picked up by one of the keepers. The steamer, *Eastland*, lays on her side in the Chicago River after rolling over at her dock. Over eight hundred passengers were drowned on July 24, 1915. The steamer was later raised and sold at an auction to the U.S. Navy. The vessel became the training ship *U.S.S. Wilmette*. It was scrapped in 1948.

This was the worst marine disaster in the history of the Great Lakes. About 1,600 employees of the Western Electric Company boarded the *Eastland* as she was docked on the Chicago River at La Salle Street. About seven thousand employees of Western Electric were taking excursion boats to Michigan City for a day picnic. As they boarded the vessel, it listed worse and worse until it suddenly capsized, trapping and drowning its victims. Improper ballasting and allowing too many people aboard were sighted as the causes.

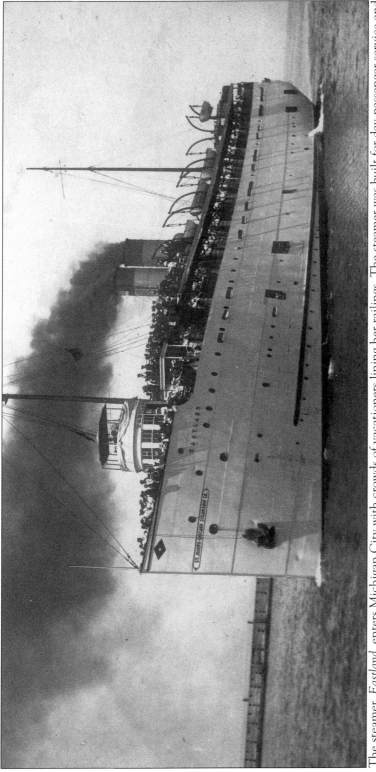

The steamer, *Eastland*, enters Michigan City with crowds of vacationers lining her railings. The steamer was built for day-passenger service and fruit cargoes across Lake Michigan to Chicago. The vessel was built in 1903, at the Jenks Shipbuilding Co. in Port Huron, Michigan. She had a length of 265 feet, a breadth of 38 feet, and a depth of 19 feet. The steamer was powered by a triple expansion engine, 21 inches by 39 inches by 56 inches by 30 inches in diameter.

The steamer's original owners were the Michigan Steamship Company, which operated the *Eastland* from Chicago to South Haven. In 1907, the steamer was sold and ran to Cedar Point from Cleveland. In 1913, the boat came back to Lake Michigan and was operated by the St. Joseph-Chicago Steamship Company. The above photo, taken by Tom Martin, captures the *Eastland* under this company's banner. The *Eastland* carried a full capacity of passengers in July of 1914 to Michigan City. This was the annual Western Electric Co. picnic, since 1911. The crowds came and gathered in Washington Park across from the lighthouse residence.

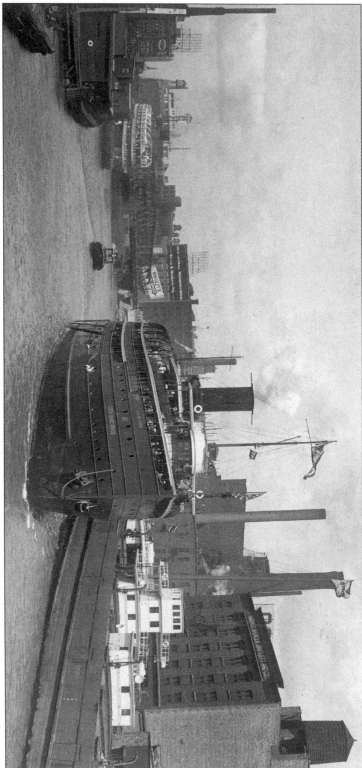

The *City of Grand Rapids* is shown above in the busy Chicago River when Keeper Martin visited Chicago. The steamer was a combination package and passenger boat built for the Graham and Morton Line on June 22, 1912. The steamer's keel was laid at the American Shipbuilding Co., Cleveland, Ohio, as hull No. 455. The ship was 310 feet long, 48 feet wide, and 27 feet deep. Her triple expansion engines put out 4,500 horsepower, and propelled her at a speed of 21 miles per hour.

The steamer could sleep up to 450 passengers. The 210 staterooms had the convenience of electric lighting and running water. In the main salon at the head of the staircase, a large mirror hung, surrounded by Paul Honore paintings. The *Grand Rapids* was known as the "honeymoon" ship. Many young newlyweds have fond memories of their special cruise on Lake Michigan.

As time passed, lake excursion boats became less popular as the automobile took over the way of travel. In the fall of 1952, the steamer was towed to Hamilton, Ontario, for scrapping.

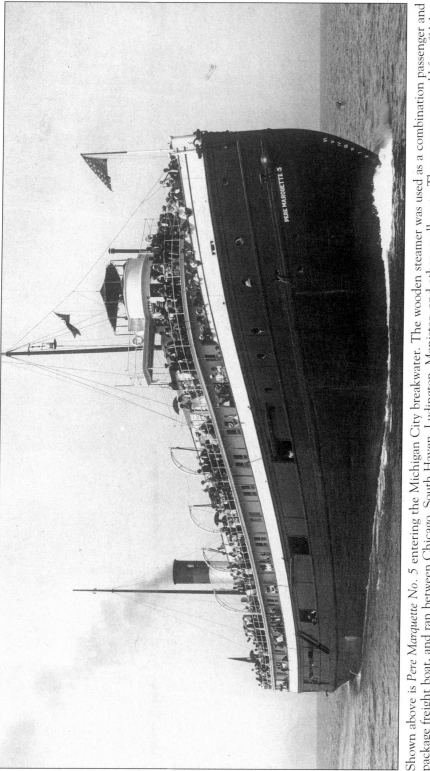

Shown above is *Pere Marquette No. 5* entering the Michigan City breakwater. The wooden steamer was used as a combination passenger and package freight boat, and ran between Chicago, South Haven, Ludington, Manistee, and other small ports. The steamer was sold for off-lakes use in 1916, and renamed *Anzac*. It sank in a storm off Nauset, Cape Cod, Massachusetts, on March 10, 1917. The 240-foot steamer was built at F.W. Wheeler Co. in 1891. The steamer was built to carry heavy cargoes of salt, grain, and flour. Its deep draft kept her from carrying full loads into shallow ports. Thus, it was chartered to many other lines during her life on the lakes. In 1898, the *No. 5* had passenger accommodations added and became more competitive in the passenger trade.

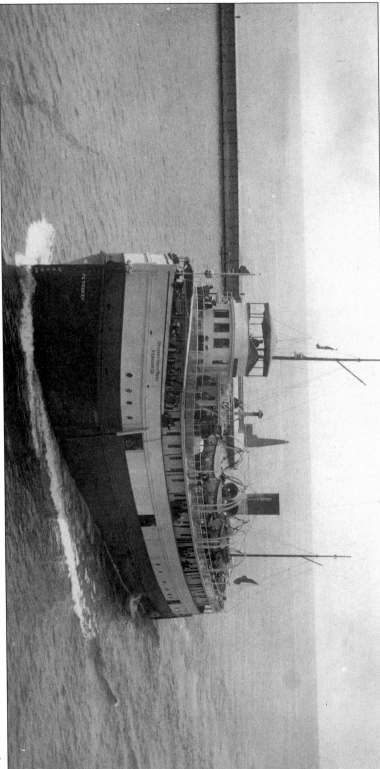

This photograph of the 171-foot steamer, *Petoskey*, entering Michigan City was taken by Keeper Martin from the East Pier Lighthouse. In this photo, the *Petoskey* is under the Chicago and South Haven Steamship Co. (1901–1927). She was built at the H.B. Burger Shipyard in Manitowoc, Wisconsin, in 1888. The steamer had a length of 171 feet, breadth of 30 feet, and depth of 12 feet. The boat's engines were 20 inches by 40 inches in diameter, by 36-inch stroke.

The *Petoskey* was laid up in 1932. Bought by Capt. John Roen of Sturgeon Bay, it was to become a barge, but it was lost to fire before this could happen on December 5, 1935.

Here is a note from Tom Martin's 1920 journal: "Jan. 8. Wind N. to N.E. mod, cloudy, colder today, 22 degrees at 6 a.m. Large field of ice to the north. Steamer *Petoskey* off in ice off Muskegon."

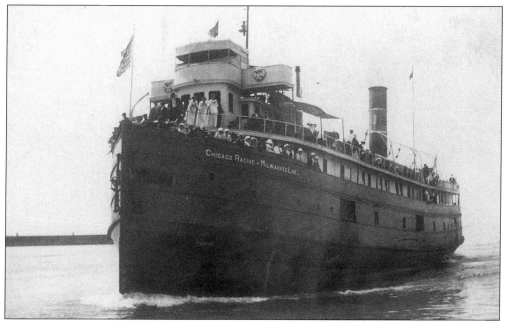

The combination passenger, freight, and steamer, *Kansas*, is shown entering Michigan City with excursionists. The vessel was built in 1870 by A.C. Keating, Cleveland, Ohio, with a length of 200 feet, a breadth of 33.3 feet, and a depth of 19 feet. In this photo, the *Kansas* was chartered by the Chicago, Racine, and Milwaukee Line from the Northern Michigan Line. On October 27, 1924, the *Kansas* was destroyed by fire while docked in Manistee.

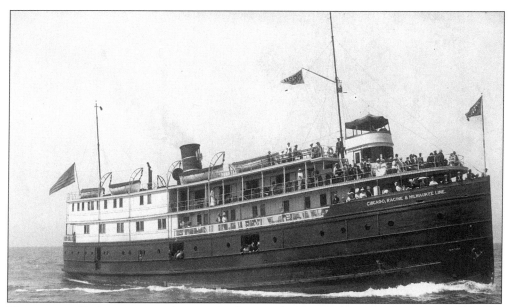

The steamer, *Racine*, was a combination package and passenger steamer. She was owned by the Chicago, Racine, and Milwaukee Line. The steamer ran between Chicago and Milwaukee, but would stop in Michigan City if traffic warranted it. It was sold to the French in 1917, and renamed *Rene*. It was scrapped there in 1931. The *Racine* was built as hull No. 81 at Craig Shipbuilding Co., Toledo, Ohio, in 1901.

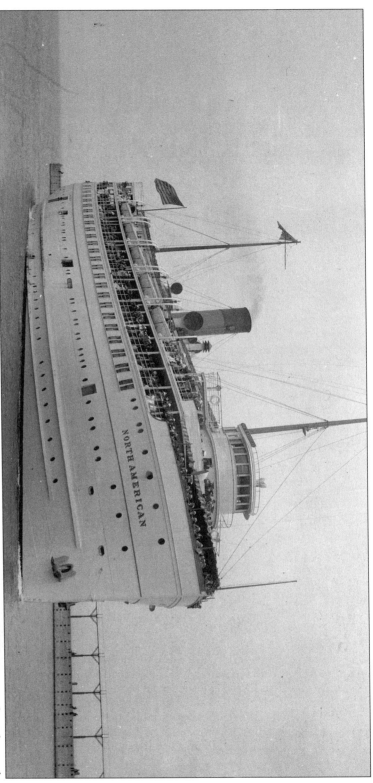

This photo of the *North American* entering Michigan City was taken shortly after the steamer went into service in 1913. A second smoke stack was added in 1924, which was a dummy and contained electrical equipment.

The *North American* was built as hull No. 107 at the Great Lakes Engineering Works in Ecorse, Michigan. The steamer has a length of 291 feet, a width of 47 feet, and a depth of 18 feet.

The *North American* and her sister, the *South American*, sailed for the Chicago, Duluth, and Georgian Bay Transit Co. for over 50 years. The ships were always painted white their entire careers and could easily be spotted as they came down the lake.

The *North American* was built for passenger service only without freight capacity. As with earlier passenger steamers which had elegant salons, furniture, etc., the *North American* was done in a simple fashion. The end came for the *North American* in 1967, after it was sold. As the steamer was towed up the Atlantic to Maryland, a storm overcame her, and she was lost.

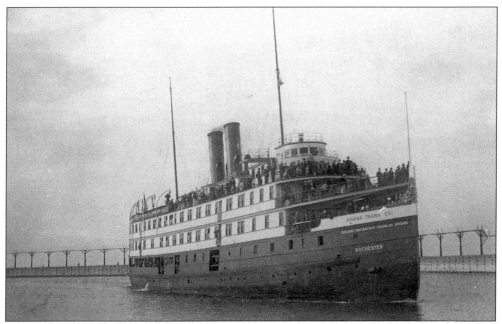

In this photo, the *Rochester* was under the Indiana Trans. Co. banner. In 1920, five years after this photo was taken, she was sold and renamed *Cape Eternity*. In 1941, the ship was sold off-lakes. The steamer was built in 1910, at the Detroit Shipbuilding Co. in Wyandotte, Michigan. The ship had a length of 256 feet, a breadth of 42 feet, and a 14-foot depth.

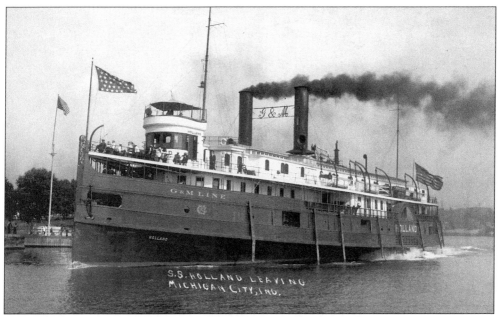

The steamer, *Holland*, is pictured heading outbound from Michigan City, past the Coast Guard Station. The steamer was named *Holland* in 1905. She was lost under the name *Muskegon* on October 23, 1919, after hitting the Muskegon Pier during entry in a heavy gale. Twenty-nine people lost their lives in the sinking. In 1881, the Holland was built in Wyandotte, Michigan, at the Detroit Dry Dock as hull No. 44 with a length of 242 feet.

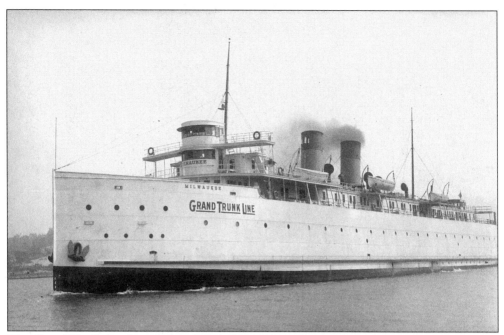

The Grand Trunk car ferry, *Milwaukee*, is shown above leaving Grand Haven, Michigan. The photograph was taken by Keeper Dykeman while visiting relatives. Launched as the *Manistique, Marquette & Northern No. 1*, the ferry was renamed *Milwaukee* in 1909. The *Milwaukee* was lost with all hands on October 22, 1929, crossing from Milwaukee to Grand Haven. The car ferry was built in 1903, at American Ship Building Co. in Ohio, with a length of 358 feet.

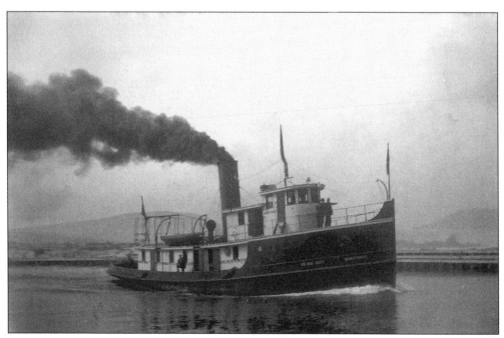

The government tug *Manitowoc* is seen entering Michigan City Harbor.

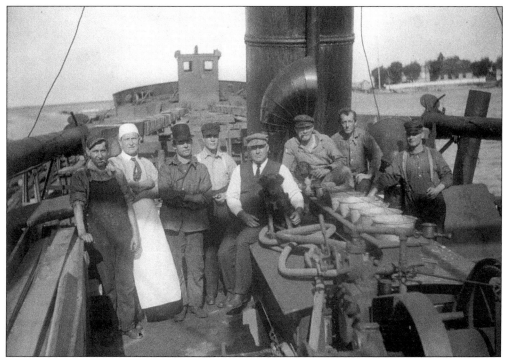

The crew of the self-unloading sandsucker, *H. Dahlke*, is seen here in the Michigan City harbor. The ship was built in 1907 at Manitowoc Dry Dock Company, Manitowoc, Wisconsin. In this photo, the vessel was owned by Lake Sand Co. The vessel was sold for off-lakes use in 1943.

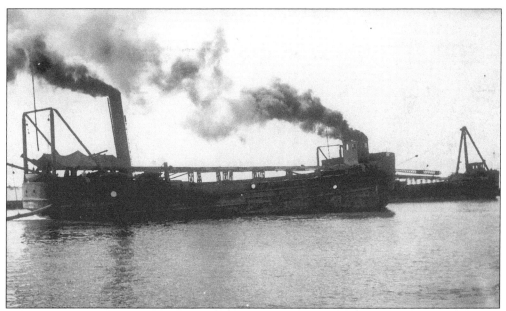

The sandsucker, *H. Dahlke*, of the Lake Sand Co. is pictured with another sandsucker, working in Michigan City Harbor in 1913. In December of 1939, 16 men and a woman cook escaped a sure death as the *H. Dahlke* turned turtle. The sandsucker was unloading a cargo of clay at Sandwiche, Ontario, when the cargo shifted and it sank.

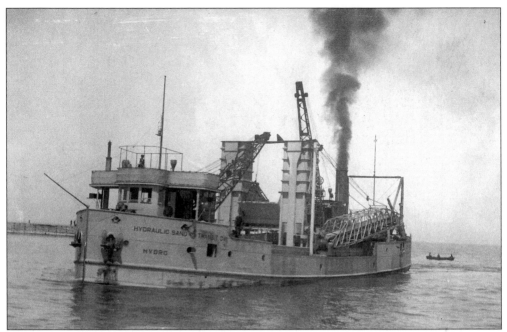

The *Hydro* was a self-unloading sandsucker which dredged up lake and river bottom sand for use in landfills, etc. Here, she was only a couple of years old, working the Michigan City Harbor.

Here the *Hydro* passes the U.S. Life-Saving Station entering the river. The sandsucker was built at Manitowoc Shipbuilding Co., Manitowoc, Wisconsin, in 1913 as hull No. 59. Her overall dimensions were 185 feet by 40 feet, 6 inches by 19 feet. The *Hydro* had a long career until 1962, when the hull was sunk and used for a dock in Erie, Pennsylvania.

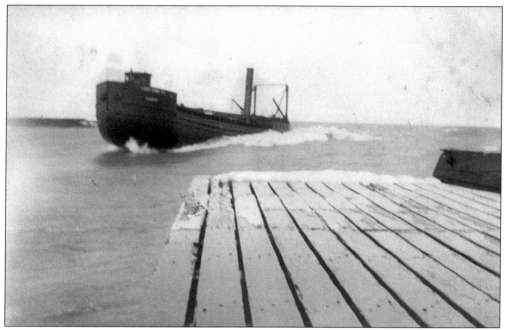

The sandsucker, *H. Dahlke*, is seen coming in during rough weather. The wind must have been strong as Fred had a hard time holding the camera still!

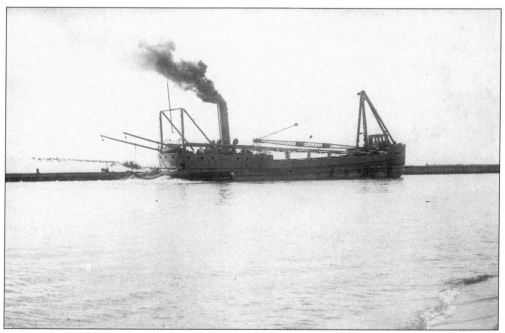

The sandsucker, *E. Gunnell*, is shown taking sand from the Michigan City Harbor. The vessel was built at Manitowoc Shipbuilding and Drydock Co. in Manitowoc, Wisconsin, in 1912. The *Gunnell* was 206 feet long, 36 feet wide, and had a depth of 16 feet. The vessel was later used as an asphalt storage barge and foundered in Seven Islands Bay, Quebec, in 1972 under the name *Transbay*.

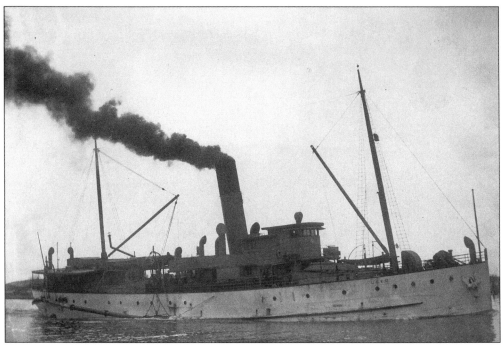

The suction dredge, *General Gillespie*, is pictured working in Michigan City Harbor. The dredge had a length of 177 feet, a breadth of 38 feet, and depth of 19 feet. She was built of steel and carried a tonnage of 1,200 tons. The ship was built at Sparrows Point, Maryland, in 1904, and serviced the harbors on the east shore of Lake Michigan.

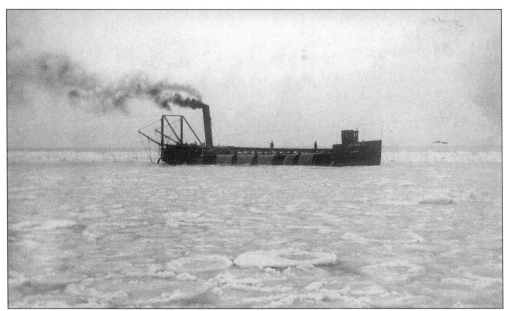

The sandsucker, *H. Dahlke*, is shown working Michigan City Harbor on March 26, 1910. The back of this postcard sent by Fred to Anna reads: "This is a picture of the sandsucker out along the beach taking up sand and taking it over to Chicago. I don't remember whether I sent you one of these or not, let me know if I did."

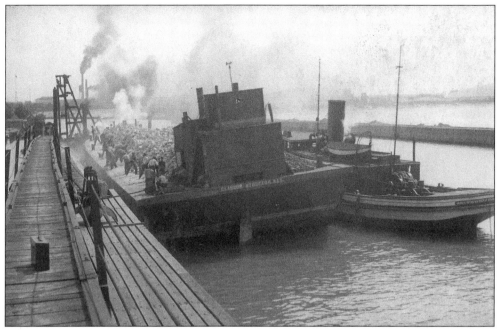

Work is being done on the East Pier at Michigan City. Note all the laborers moving the stone on the barge. The tug, *John Hunsader*, is tied alongside the *Glasgow*.

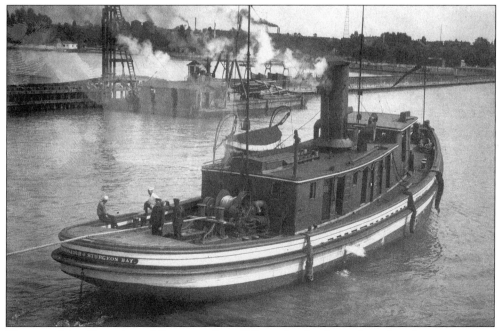

The tug, *John Hunsader*, of Sturgeon Bay, Wisconsin, is pictured towing the stone scow, *Glasgow*, of Sturgeon Bay, into Michigan City.

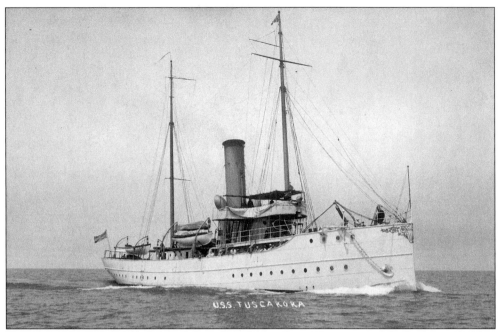

The revenue cutter, *Tuscarora*, entering Michigan City. The steamer was built in 1902, in Richmond, Virginia. The vessel had one gun and displaced 670 tons. The *Tuscarora* was stationed in Milwaukee, Wisconsin. In 1930, the *Tuscarora* was transferred to St. Petersburg, Florida. She remained there in service until being cut up for scrap 1937.

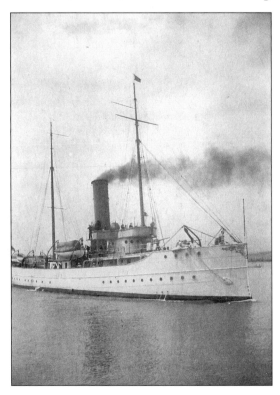

Pictured here is revenue cutter, *Tuscarora*, underway at Michigan City.

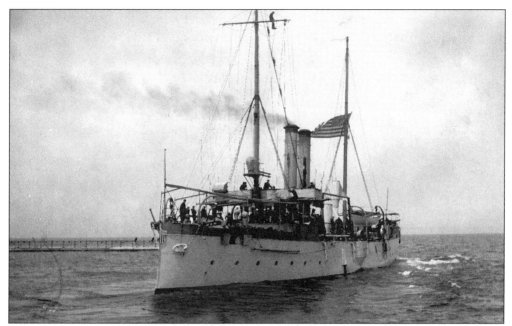

The United States Training Ship, *Isla De Luzon*, enters the Michigan City Piers. Sir W.G. Armstrong built the ship in 1887, in Newcastle-upon-Tyne, England. The vessel had a length of 192 feet, a width of 30 feet, and a 12-foot depth. It was made of steel with 2,700 horsepower and a speed of 16 knots.

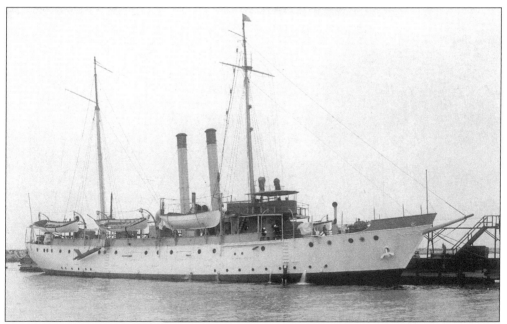

The naval training vessel, *U.S.S. Dubuque*, docked next to the pier in Michigan City. The vessel was commissioned on June 3, 1905. She had a length of 174 feet, a beam of 35 feet, and a displacement of 1,085 tons. The *Dubuque* served in World War I and later as a training ship on the Great Lakes.

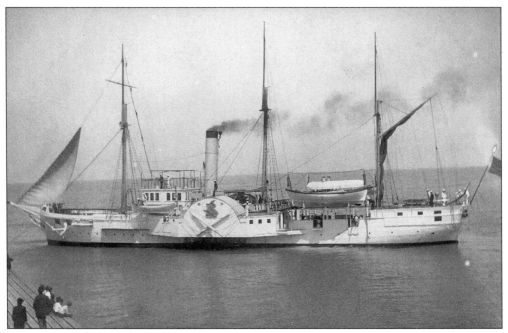

The *U.S.S. Wolverine* (Ex. *U.S.S. Michigan*) is pictured off the Michigan City piers. The *Wolverine* was commissioned on August 9, 1843, and launched in Erie, Pennsylvania. The *Wolverine* was the first iron ship of the United States Navy, and also the first iron ship to sail the waters of the Great Lakes. In the above photo, she was being used as a training ship. The *Wolverine* was laid up in 1923.

A small launch from the yacht club moves down the channel. The large flag above the yacht reads "Senator."

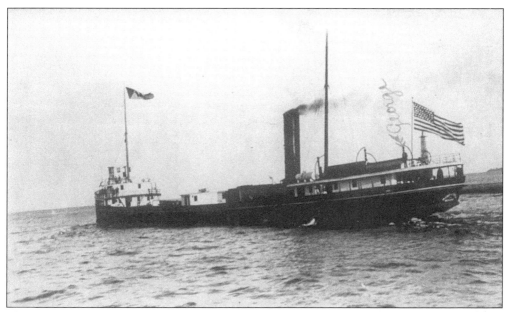

This card of the steamer *Manchester* leaving Milwaukee on August 3, 1914, was sent to Fred Dykeman. Fred's friend George Zurncer went sailing on the Great Lakes. The back of this card reads: "How is everything in the old town? Do you see the sand boats? I saw the *Hydro* at So. Manitou after a load of gravel. I suppose everything is fine here and the weather also."

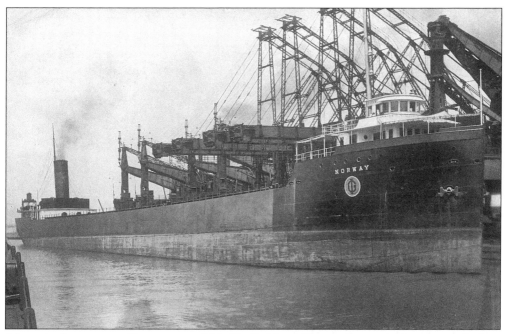

Above is the steamer, *Norway*, on which Fred's friend George Zurncer shipped out. A short note to Fred on the back read: "Well, thought I would drop you a card of the boat I am on this year. At the ore dock in Conneaut, Ohio. The *Manchester* is not running, but times are kicking up a little now." The ship was built in 1910 at the Toledo Shipbuilding Co.

The three-masted schooner, *Alice*, sailed into Michigan City to deliver loads of lumber and other goods for years. The boat had a capacity of 350,000 board feet of lumber. Here the sailing ship is near the end of her Great Lakes career. On February 4, 1918, it was sold for off-lakes use to Port Arthur, Texas, hauling lumber. It was finally abandoned in 1930, because of the schooner's deteriorating hull.

The schooner *Alice* enters the Michigan City Harbor. As late as the 1920s, sailing vessels still arrived at the harbor. But the days of the romance of the sailing ships were drawing to a close. The *Alice* was built in 1881 at Manitowoc, Wisconsin, as official No. 105999. She was 137 feet long, 30 feet wide, and had a depth of 9 feet. The vessel carried a crew of six.

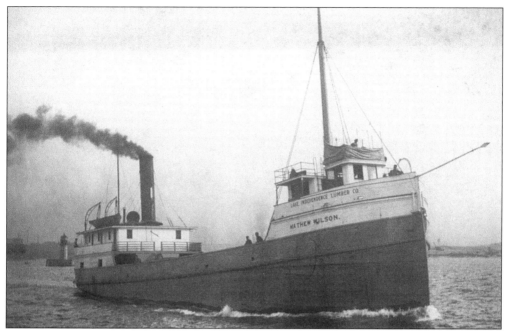

The lumber hooker *Mathew Wilson* is shown departing Michigan City. When this photo was taken, she was owned by Lake Independence Lumber Co., Cleveland, Ohio. She had overall dimensions of 150 feet by 28 feet, 8 feet by 12 feet. The vessel was scrapped in 1934.

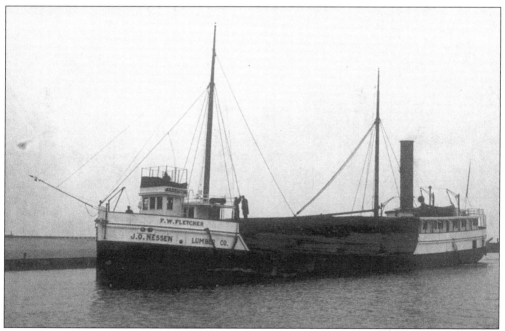

In this photo, the lumber hooker, *F.W. Fletcher*, was operated by the J.O. Nessen Lumber Co. It was built in 1891 by Alexander Anderson Shipyard, Marine City, Michigan. The ship and overall dimensions were 170 feet by 11 feet. She had a carrying capacity for 550,000 board feet of lumber. The vessel was scrapped in 1917.

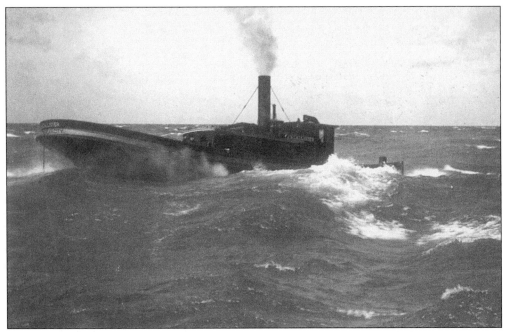

The tug *J.W. Callister* is shown here heading out in rough seas on a March day in 1913. Tom Martin wrote to Fred on the back of this postcard: "Rotten, cold here now. It was zero this a.m., it is only 8 above zero now at 4:00 p.m. The *Callister* had quite a time getting in last night, there was so much ice."

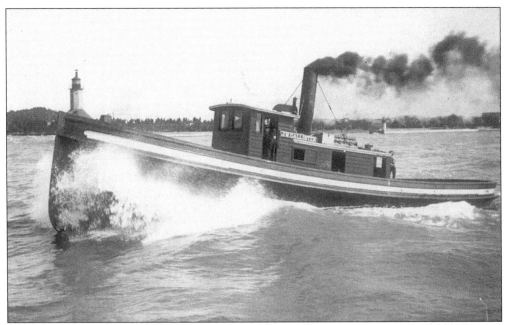

The tug *J.W. Callister* heads outbound from Michigan City. The tug was built as a fishing tug, but above she is shown as a towing tug. The boat was built in Grand Haven, Michigan, in 1890, with the official No. 76890. The tug had a length of 60 feet, a breadth of 13 feet, and a depth of 5 feet. Her port of call was Grand Haven, and a crew of seven operated her.

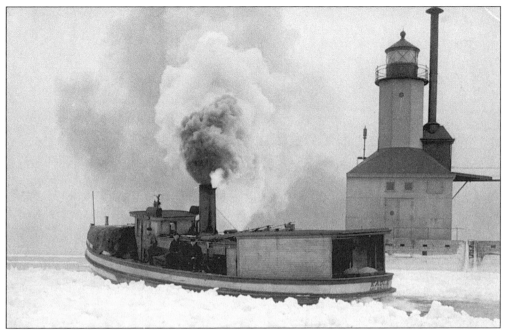

This card was written to Fred on February 4, 1916: "Dear Friends, Rec'd your card this a.m. will tell the mailman as you requested. This is one I took of the *Eagle* this morning. She had a hard time getting out, there is no open water in sight except a strip along the beach. Best regards from all, Tom & Lottie."

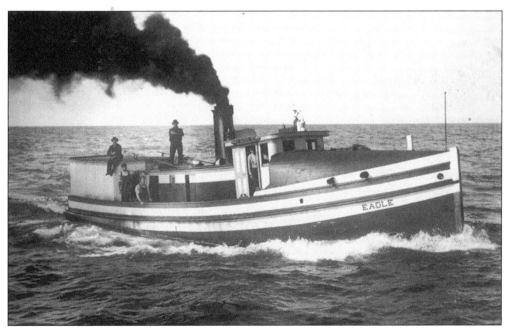

The fishing tug, *Eagle*, heads in after a day's haul of fresh lake fish.

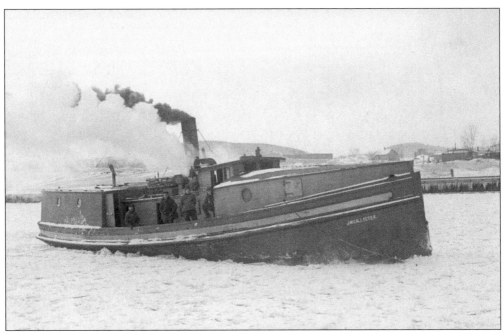

The fish tug, *J.W. Callister*, breaks the ice on February 13, 1915. Tom Armstrong sent this card to Fred: "Your cards received and glad to hear that your mother arrived ok. We are having a regular summer's afternoon here, although it rained nearly all forenoon. The tug *Callister* went out and set nets this morning. Everybody is well and happy so far as I know. I have been working up an appetite on the wood pile."

The tug, *J.W. Callister*, heads outbound, fighting a heavy sea.

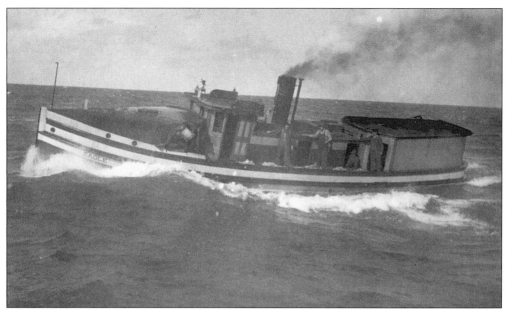

The fishing tug, *Eagle*, rolls as she leaves behind Michigan City heading for fishing grounds. The *Eagle* was built in 1905 in west DePere, Wisconsin, and was given official No. 201976. The tug was built with a length of 50 feet, a width of 10 feet, and a depth of 5 feet. The boat was home-ported in Milwaukee, Wisconsin, and pushed by 16 horsepower.

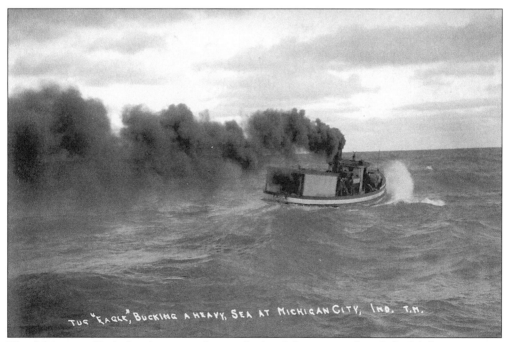

The fishing tug, *Eagle*, heads out in a big sea for her fishing grounds in Lake Michigan.

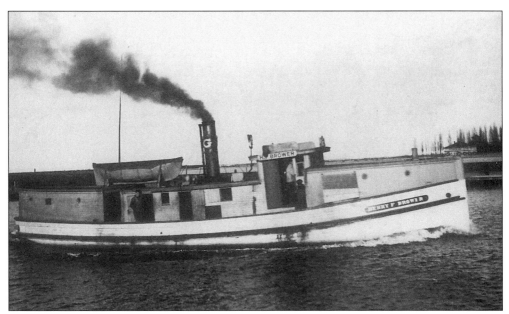

The fishing tug, *Henry F. Brower*, enters Michigan City after gathering a days' catch. Built in Grand Haven, Michigan, in 1882, the tug was home-ported out of Marquette, Michigan. The vessel was 15 net tons, and built with a length of 60 feet, a breadth of 15 feet, and depth of 6 feet. A four-man crew worked the *Brower*.

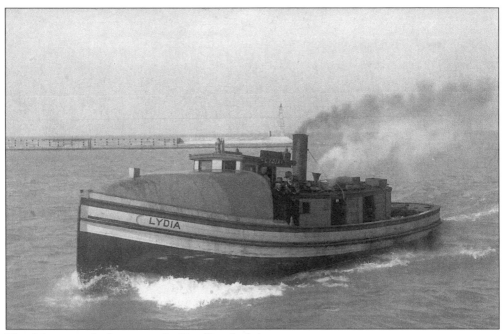

The fishing tug, *Lydia*, passes the East Pier Lighthouse.

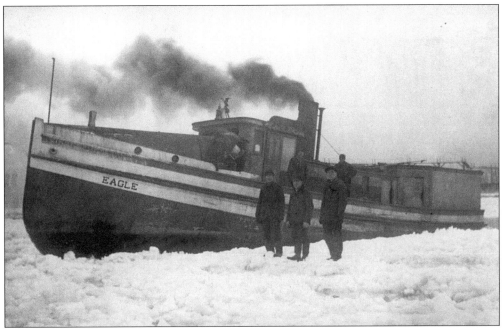

The following is from Tom Martin's 1920 journal: "January 1, S.W. to W. Mod to fresh snow, 6 a.m. lake full of slush ice, harbor frozen solid. The tugs *Margaret* and *Eagle* lifted their last nets yesterday and *Dornboss* went to Chicago."

The fishing tug *J.W. Callister* is seen here at her dock in Michigan City. Note all the fishing nets behind the tug.

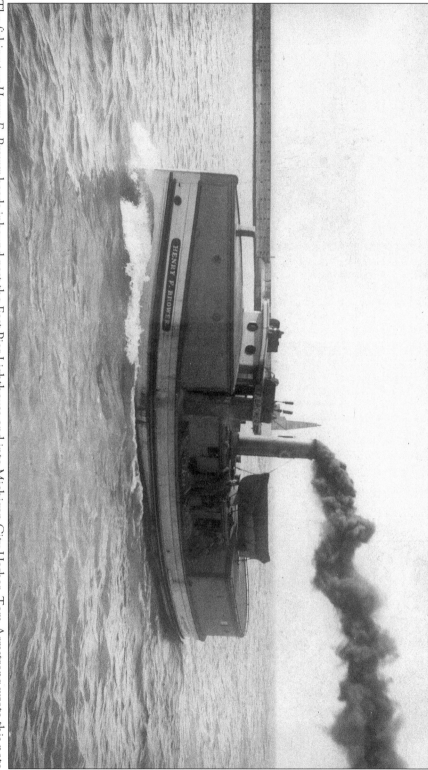

The fishing tug *Henry F. Brower* heads inbound past the East Pier Lighthouse and into Michigan City Harbor. Tom Armstrong wrote this note to Fred on February 23, 1913: "Your cards rec'd all ok and glad to hear you both were well and getting along in the same old way. Ice all gone. *Ludwick* and *Purvis* are fishing again. Sutz is going to build a tug for himself. Went out and took a few views today. Martin has been slicking up the hall and stairs while you are gone. I haven't got my job on the boat yet. Folks all going to Chicago Wednesday and Thursday, so I won't be back it for a few days."

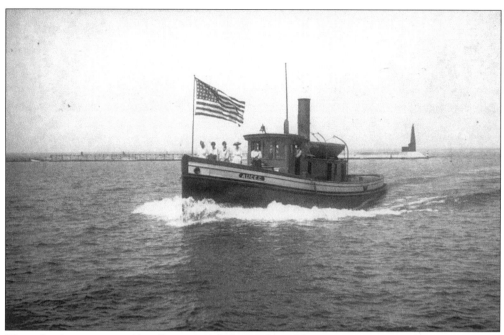

The inland-towing tug *Alice C.* enters Michigan City. The tug carries some excursionists after a tour of the big lake. Note the large American flag on the bow. The boat was built in Manitowoc, Wisconsin, in 1901. The *Alice C.* was 63 feet long, 18 feet wide, with a depth of 8 feet. She had a net tonnage of 27 tons.

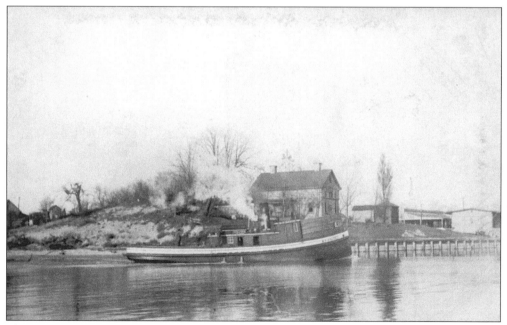

The tug, *B.F. Bruce*, passes the lighthouse residence. The working tug was built in Buffalo, New York, in 1873 as official No. 2861. A length of 58 feet and a breadth of 15 feet made this a good harbor tug. A crew of five men operated the *Bruce*. These tugs helped move the passenger ships around the tight bends in the harbor.

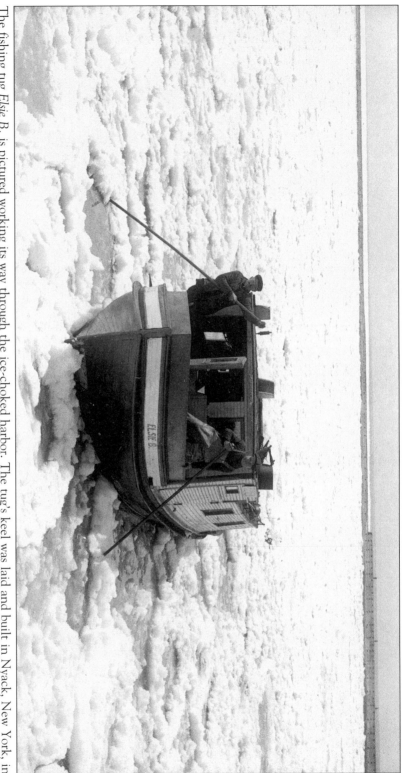

The fishing tug *Elsie B.* is pictured working its way through the ice-choked harbor. The tug's keel was laid and built in Nyack, New York, in 1901 as official No. 136880. Her length was a small 46 feet, 11 feet breadth, and 4 feet depth. A crew of three manned this fishing tug. In February of 1915, Tom Martin wrote that the weather here is "real spring-like. The *Callister* and *Elsie B.* are fishing, commenced Monday." On January 19, 1914, Head Keeper Thomas Armstrong wrote this letter to Fred:

We have had fine weather so far, till today. Has been snowing all day, but not very cold. This is one of several views I got on the 13th. Was out to breakwater on the 16th and also rec'd gas tank the same day and it's been only today we could get up the harbor with the boat. The tug and Elsie B. are still fishing.

78

Six

U.S. LIFE-SAVING AND U.S. COAST GUARD

They were a very special breed of men; some called them the "heroes of the surf," others, "storm warriors." But when a storm raged and turned most deadly, they were the ones who walked the wind-swept icy beaches on patrols, looking for those in distress. They were the men who rowed their lifeboats through howling gales, sleet stinging their reddened faces, the cold numbing their hands as they gripped onto the oars fighting to reach and save shipwrecked mariners in peril. All through the annals of our nation's history, there are no stories more full of heroism and devotion than these.

The forerunner of the U.S. Life-Saving Service was the Massachusetts Humane Society, which built huts along their shoreline in 1787. These small buildings would give shelter and food to shipwrecked mariners and passengers.

It was not until April 20, 1871, that Congress officially put aside money to bring into existence a life-saving system. Stations were slowly built throughout the U.S., and the service was better organized under the able leadership of Sumner Kimball. Under his direction, the U.S. Life-Saving Service was divided into 13 districts, Lake Michigan being placed in the 12th. This district eventually contained 31 stations along its shores.

One of these lifeboat stations was established at Michigan City. It was opened on April 28, 1889, under the command of Henry Finch. The station was located on the east side of the harbor, just north of the lighthouse residence.

The station consisted of three buildings. The main house contained the offices, crew quarters upstairs, and a lookout perched on top. A boathouse with a launching ramp was also a part of the dwelling. The second structure was used for the crew's mess hall and workshop. The last small building was stable and was later used as a garage.

Along with Head Keeper Finch, there were six surf men assigned to the stations. The men were numbered one to six, the first having the most experience. Although these men braved storms and rescued many sailors, there were also the hours spent in drilling and patrolling the long stretches of beach. Their logs read much like that of Tom Martin's at the lighthouse. Working many odd jobs around the station—cutting grass, painting, cutting and piling firewood, etc.

The three keepers, Martin, Dykeman, and Armstrong all shared a special bond with this sister service. Their duties at the light often took them to the station where they became friends with Captain Michael Egle in charge. They went on outings with the families of surf men, Charles Marshall, Frank Lee, Ole Thorsen, and the others.

Captain Egle served at the station from 1908 until 1919, when he was relieved by Captain W.E. Preston. Egle guided the station through the transition when the U.S. Life-Saving Service and Revenue Cutter Service joined to form the U.S. Coast Guard in 1915.

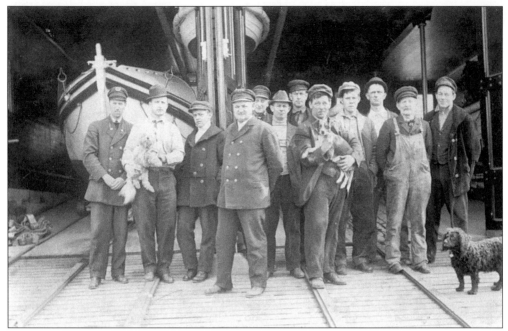

Photographed here is the Life-Saving Station in Michigan City. Second Assistant Keeper Fred Dykeman is on the far left, and Captain Egle is standing front center. The back of this card states that the puppy on the left was rescued by the crew and brought back with them.

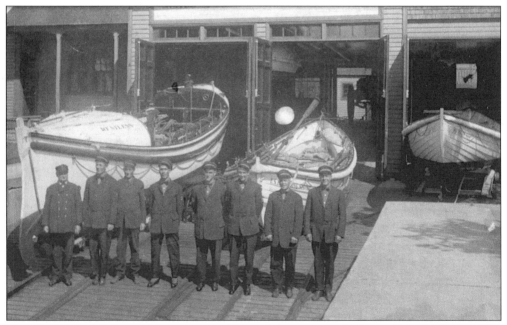

Captain Michael Egle and his seven-man life saving crew pose in front of the Michigan City Station. The station schedule called for cleaning the facility on Saturdays.

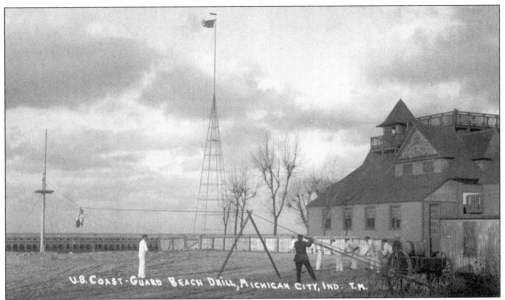

"Mondays and Thursdays were given over to beach apparatus drill which consisted of shooting a projectile, with a line attached, by means of a cannon-like instrument called a Lyle Gun. The projectile, aimed toward a drill pole, carried the line that would be used for hauling the breeches buoy or life car." This drill was required to be completed in five minutes. Today the drill pole and practice are but a memory.

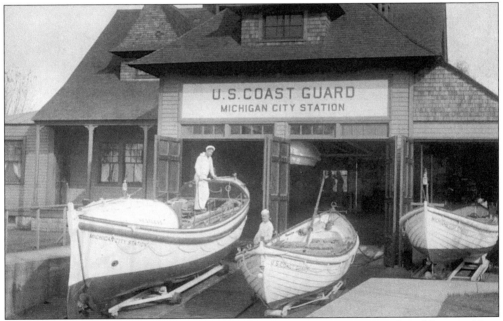

The Michigan City Station is pictured shortly after it became a U.S. Coast Guard Station. Note the 36-foot motor lifeboat on the far left. The Michigan City Life-Saving/Coast Guard Station served the waterfront well, upholding the finest tradition of the service. The station has changed in its appearance over the years. A new building has replaced most of the old. In 1967, the garage and shop building were removed.

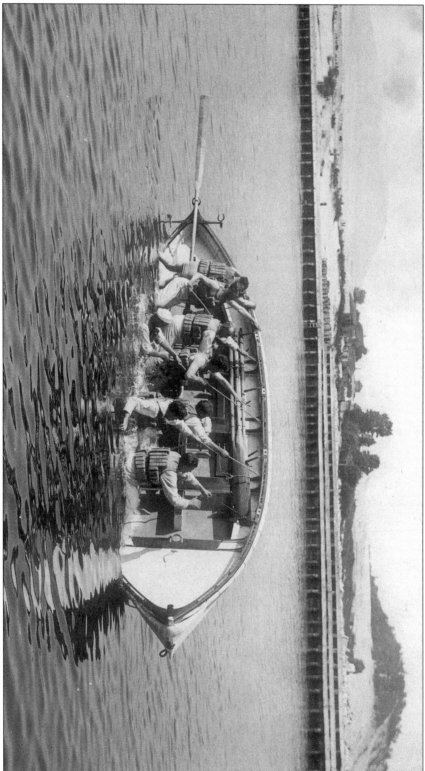

The lifeboat is about to go over as the crew practices rolling the surfboat. Many Life-Saving Stations liked to put on surfboat drills for the area crowds in the summer. Michigan City was no different, as the banks of the river would be lined with onlookers. The surfboat was deliberately capsized by the crew and righted to simulate a real situation that may occur during a rescue. On a calm day, the crew could roll the surfboat and hardly get wet. During the 1907 Jamestown Exposition, a crew capsized and righted the boat in 13 seconds! Many of these crews liked to compete with other crews to show their skills, and also to keep a razor-sharp edge on training that could mean life or death during a rescue.

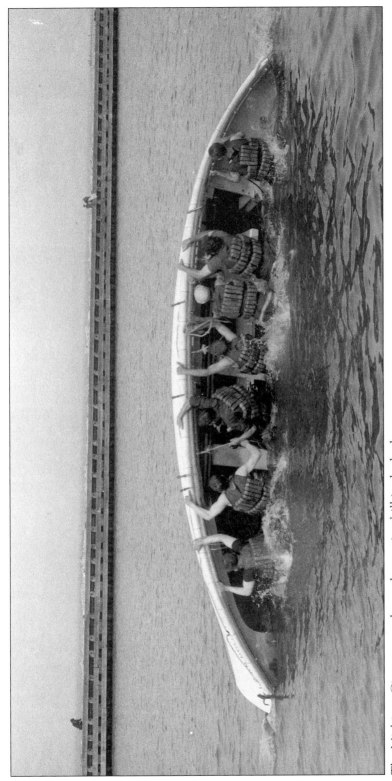

The Michigan City crew works on the capsize drill in the harbor.

On July 10, 1913, Second Assistant Keeper Fred Dykeman received a postcard from his sister Etta. "Arrived in Grand Haven at noon. Aunt Ida just got back from Captain Morton's funeral. Uncle Jake was here also. All the Captains walked in a body and the lifesavers were the pallbearers. They took him to the depot to be buried at St. Joseph."

Captain Charles Morton had a remarkable career in the U.S. Life-Saving Service for 31 years. He resigned in 1911, as superintendent of the 12th Life-Saving District, and in this capacity visited the Michigan City Station.

Before coming to the service, Morton had served on the frontier in the 7th Calvary, and fought with Colonel George Custer. He survived the Battle of the Little Bighorn, July 25–26, 1876. Captain Morton was born in Ireland July 12, 1853, and died July 7, 1913.

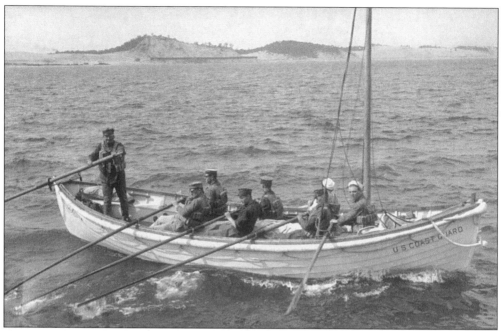

The 26-foot surfboat is seen here with Captain Egle at the tiller. Note that the surfboat bow lettering reads: "U.S. Coast Guard." The U.S. Life-Service has been replaced.

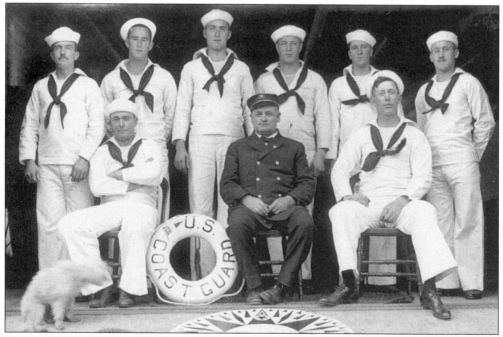

Captain Michael Egle and his new U.S. Coast Guard crew are shown at the Michigan City Station in 1915. The outreach of the service is the same today as in the past: to rescue those in peril, with the motto being "Always Ready."

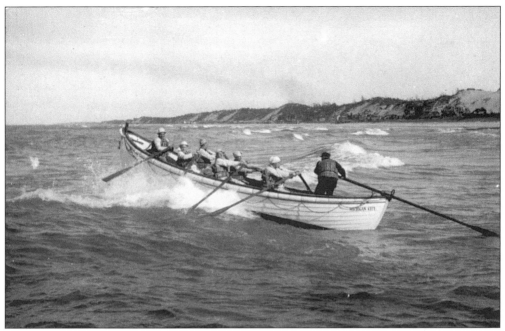

Captain Michael Egle and his Life-Saving crew are shown practicing rowing in their 26-foot surfboat off Michigan City. Launching the surfboat through the surf with at least a half-hour at the oars was done on Tuesdays.

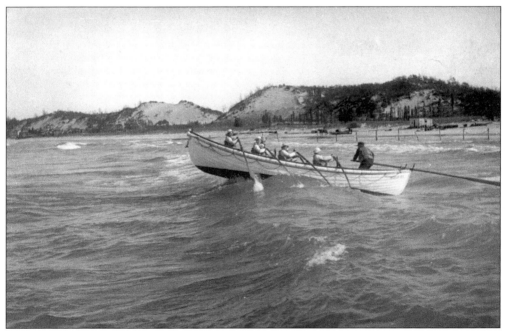

Here is another shot of the U.S. Lifesavers working in the surf. Note the sand dunes in the background.

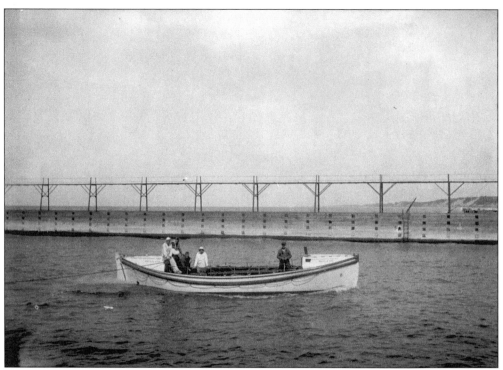

The Michigan City Life-Saving crew is pictured here towing a small boat. On the stern of their 36-foot motor surfboat, the name *Restless* is visible. On the bow, *U.S. Life-Saving Service, Michigan City* is visible. In 1909, the gasoline motor was added to the station.

The motor lifeboat tows a small disabled craft. Note the U.S. Life-Saving emblem on the lifeboat bow.

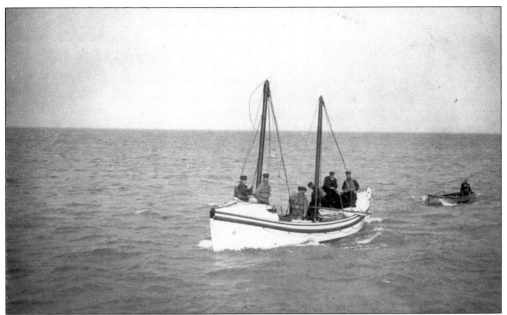

This motor lifeboat is towing a small boat. Captain Egle is at the tiller, and the six members of his life-saving crew are shown. On October 23, 1920, Captain Egle had the harbor tug, *Bird*, go out and look for the overdue tug, *Margaret*. On October 24, *Bird* returned with the disabled tug in tow.

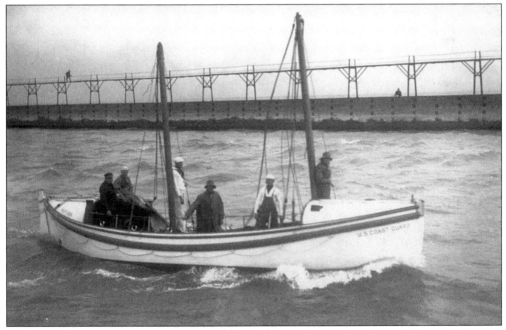

The U.S. Coast Guard's 36-foot motor lifeboat moves down the channel. Two of the crew members are wearing their foul-weather slickers.

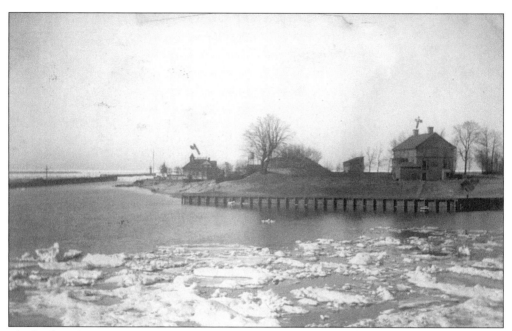

The back of this card is of special interest, as it was written the day Fred arrived to start his new job as second assistant keeper on July 5, 1909. "I arrived in Michigan City at 11:10 this morning. The cross over the house is where we are living and 'y' over the building is the Life-Saving Station and the rest is the lighthouse and piers."

The back of this card from Fred reads: "This is taken from the wireless tower halfway up and you can see the house and Mrs. Armstrong's mother by the back door. See her? Can you not just make out that it is her? Will close, hoping you all are well."

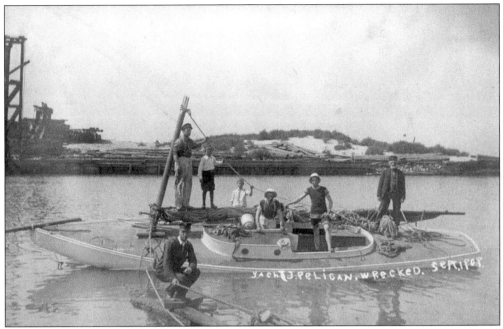

This photo was taken in front of the U.S. Life-Station on June 22, 1908. The wrecked yacht is the *J. Pelican*. Standing up on the far left is a member of the U.S. Life-Saving Service. Kneeling on the far left in the foreground is Second Assistant Fred Dykeman. Captain Egle and his crew rescued the crew of the yachts *Apohagui*, *Mokahi*, *Viola II*, and *Adventure*. Their fast action saved many lives!

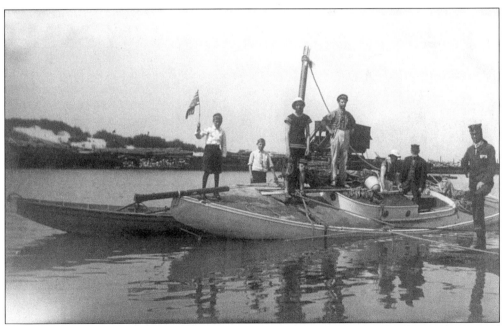

Shown above is another photograph of the wrecked yacht, *J. Pelican*. Fred Dykeman has moved to the foreground on the right. Notice the small boy on the left holding up the American flag upside down for a vessel in distress. The yachts were overcome by a sudden heavy squall, which hit the sailboats as they reached the end of their race from Chicago to Michigan City.

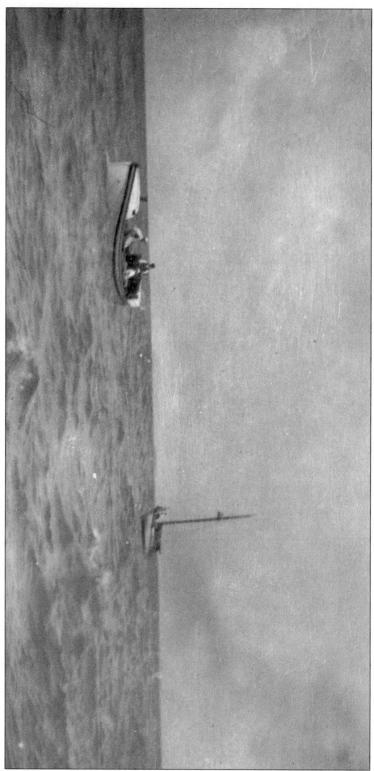

The U.S. Life-Saving crew's motor lifeboat is shown towing a disabled sailboat back to Michigan City. This is one of the disabled yachts from the June 22, 1908 race.

The sloop yacht, *Apohaqui*, was the first to run into trouble that day. The evening had turned pitch black, and a summer squall had struck so hard and fast that the boat was overturned, throwing the crew into the lake.

A surf-man on watch spotted the yacht about a mile northeast of the station and had quickly alerted Captain Egle, who then assembled his crew and launched the surfboat.

Arriving in the area, the lifesavers searched without success until lightening flashes across the sky revealed the capsized yacht's hull and five men clinging to her. The yachters were quickly taken aboard the surfboard and brought back to the station. There the survivors were given immediate care by the lifesavers and two attending physicians.

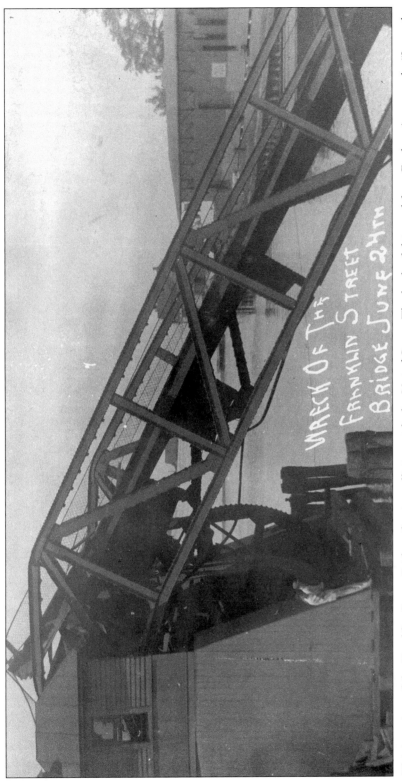

WRECK OF THE
FRANKLIN STREET
BRIDGE JUNE 24TH

This is a view of the Franklin Street Bridge after its collision with the *United States*. The back of this card from Fred to Anna reads: "I saw the whole thing happen from the house and am a witness when they have a trial, if they put it in court. I printed over a hundred cards for tomorrow, and just got done with supper and set down to write these few lines to you."

The Indiana Transportation Company's dock on the Trail Creek was situated on the very tight turn. The Franklin Street Bridge was located right behind the ships' landing. A tugboat was usually called upon to give the steamer help in maneuvering in and out of this close area.

At the time of the accident, the *United States* was only a year old. The steamer was the running mate of the *Theodore Roosevelt* for the route between Chicago and Michigan City.

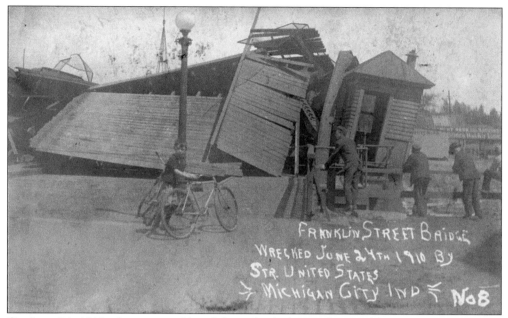

On June 24, 1910, the steamer *United States* backed into the Franklin Street Bridge while maneuvering from her river dock at Michigan City.

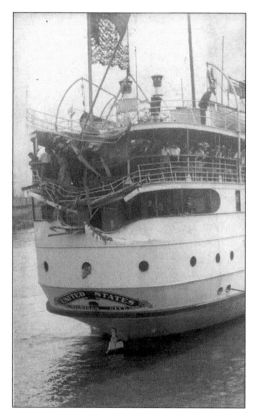

The back of this card written to Anna from Fred Dykeman, second assistant light keeper reads: "This is the stern of the *United States* after she ran against the bridge. Looks nice, does it not? I am up to the house and it is starting to blow a gale."

Seven

1913 STORM

The storm that enveloped the Great Lakes with such terrible force from November 7–10, 1913, was the most destructive to ever hit the Great Lakes region. A total of 13 freighters went to the bottom of the raging lakes, and six more were constructive losses. Another 20 freighters limped into ports or were stranded on various shorelines. The deepest loss, felt by all, was the drowning of 235 seamen who would never return to their families and friends.

The storm first struck Lake Superior on November 7, from the northwest. The winds built to a velocity of 68 miles an hour, bringing along with them a blinding wall of driven snow. As it swept down Lake Michigan, its destructive power was felt along the shoreline communities. In Milwaukee, the entire south breakwater, then under construction, was almost totally demolished. It was a loss of well over $100,000.

The first vessel that fell victim to the storm was the old wooden steamer, *Louisiana*. It ran hard aground on Washington Island, Saturday at 2 a.m. The steamer caught fire and burned to a loss, with the crew all reaching safety in their lifeboats.

Throughout the day, the United States Weather Bureau relentlessly telegraphed its storm warning to the stations around the lakes:

"HOIST SOUTHWEST STORM WARNINGS TEN A.M. . . . STORM OVER UPPER MISSISSIPPI VALLEY MOVING NORTHEAST. . . BRISK TO HIGH SOUTHWEST WINDS THIS AFTERNOON AND TONIGHT SHIFTING TO NORTHWEST SATURDAY ON UPPER LAKES. . . WARNING ORDERED THROUGHOUT THE GREAT LAKES. . . ."

In the harbor at Michigan City, the storm flags were immediately hoisted at the Life-Saving station. As they were raised, the wind grabbed the signals and whipped the material taut in the ever increasing hurricane.

As the weather deteriorated, it became more difficult for the men attending their duties at the light station. Thomas Martin, Fred Dykeman, and Thomas Armstrong were unable to maintain the light on the east pier, as winds swept the waves over the catwalk and snow made visibility almost zero. Every attempt became humanly impossible. For the next three days, they took refuge with their families in the lighthouse keepers' residence waiting for the storm to subside.

During these three days, the wind raced down the entire length of Lake Michigan, driving waves before it. Their force was unleashed against the harbor piers and lighthouse, pounding it mercilessly. As the storm front finally passed, the keepers were able to get out and assess the storm's damages.

The grounds around the lighthouse quarters were littered with branches and trees split wide open. Out past the Life-Saving station, the keepers saw their first real glimpse of the savage destructive power of the storm. A gaping hole of over 200 feet was left where once the pier and catwalk stood, allowing the keepers access to their lighthouse. The engineer corps came through with a temporary answer to the problem. They rigged an aerial tram, which was in use for two months until the pier was repaired.

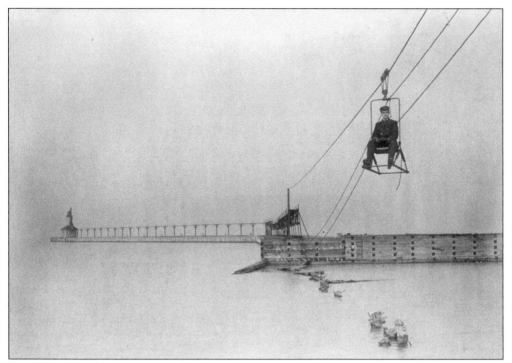

First Assistant Thomas Martin rides the aerial tram across the missing break wall to resume his duties. The framed seat was constructed of metal with pulleys attached to the top of the frame.

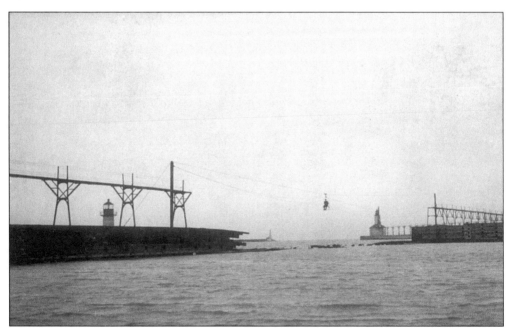

Photographed here is another view of one of the light keepers riding the aerial tram back form their watch on the East Pier Light.

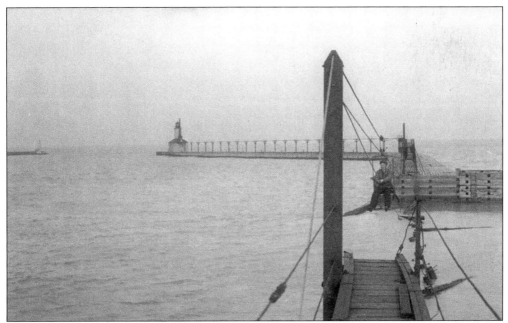

A friend of one of the keepers rides the aerial tram. His face reflects the excitement of the trip between walkways.

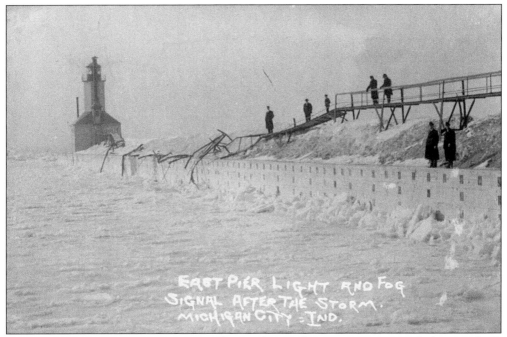

The damaged catwalk on the East Pier is shown after a February storm in 1910. Sightseers check the damaged walkway left dangling in the channel.

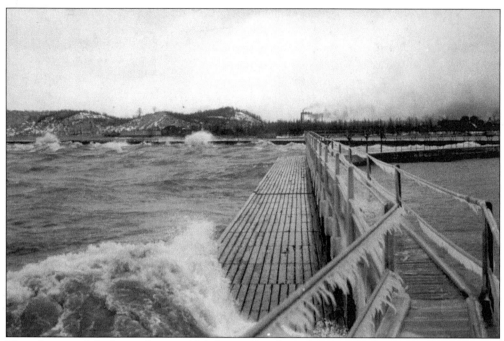

This photograph looks south toward Michigan City from the catwalk above the East Pier. Note the ice built up on all the handrails and waves breaking over the boardwalk.

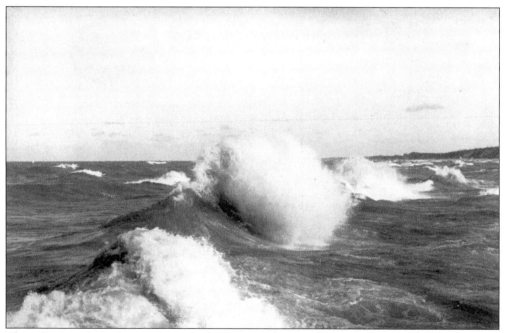

This photograph looks east from the pier on a blustery day on Lake Michigan. The wind blowing down the full length of Lake Michigan can cause enormous waves.

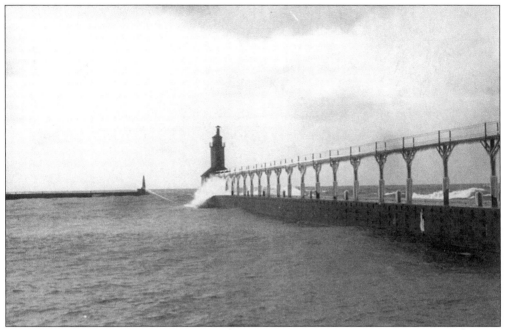

The East Pier Break wall is seen here as a huge wave begins its track down the catwalk.

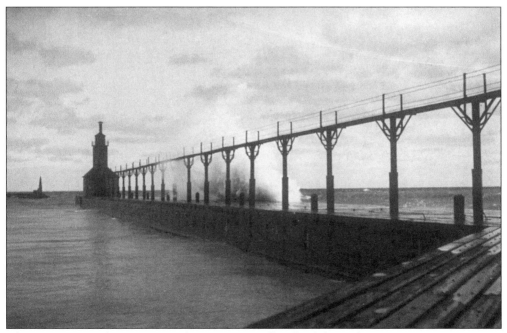

Thomas Martin's photo captures the wave as it rolls inland down the pier.

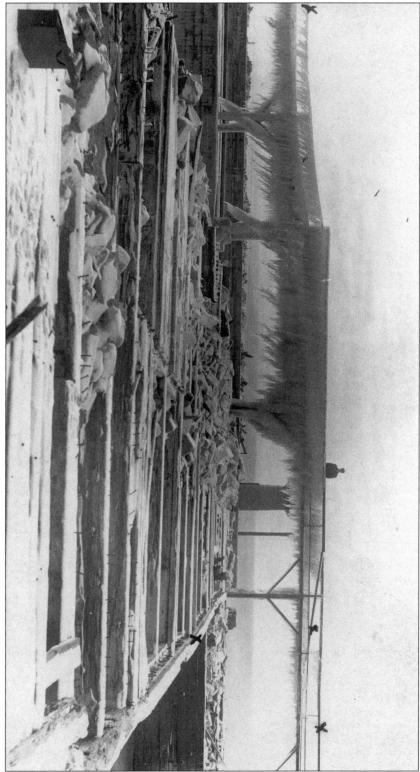

This postcard from Fred to Anna reads: "This is the tram way by the west breakwater. Where I have the X on the timber of the picture is where the seas hit the breakwater and go clear over the tram way. Where you see the two XX is going out to the signal and it shows where the railing is broken. Where you see the one X on the tram way to your left is showing that is the way going to shore. You can see the west pier tower. A person could just get through on the tram way when the ice was up there. We chopped it all down the next day but it is just as bad, if not worse again, and more of the railing is down."

98

Eight

FOGHORN

The white passenger steamer, *Theodore Roosevelt*'s sharp bow sliced through the glassy surface of Lake Michigan. The sun shone off the sparkling swells this fine July afternoon. Suddenly, the air became cooler and the light began to diminish. The horizon gradually faded, and a fog bank slowly grew, enclosing the ship in a veil of mist.

As the steamer approached Michigan City, the mist became thick as a blanket when the anxious crew and passengers heard it. That ear-shattering growl of the foghorn, vibrating through the air with a low roar.

The captain of the *Theodore Roosevelt* checked down the steamers headway and was now able to safely make the harbor entrance as it came into view through the haze.

The foghorn had been a part of the Michigan City harbor for many years. It guided in the early sailing schooners, bringing in lumber and other goods to a growing lakeshore town. The many passenger steamers that ran from Chicago and St. Joseph often depended on this steam signal. There were also many fishing tugs whose livelihood depended upon this signal to get them home during the many seasons they put out into the lake.

The foghorn had gone through several changes as to the means of powering it. In 1861, it was driven by a hand-crank to blow the whistle. Later it was a steam-powered whistle, and in the Coast Guard era it became an electrically activated horn.

The evening dispatch of November 13, 1905 carried a story titled "Larger Fog Horn in Station Here." The article went on to say that the lighthouse tender *Hyacinth* had installed a larger foghorn—10 by 80 inches replacing a 10 by 16-inch horn. It had its first test the following morning, when the steamer *John Schroeder* arrived off the harbor in the fog and exchanged whistle signals to safely find the harbor location.

There was also a short piece in the dispatch on December 9, 1905: "Owing to the continued smoky condition of the atmosphere over this end of the lake, the fog signal has been kept fired up continuously during the past sixty hours and the whistle has blown at intervals during most of that time. The northwest wind, which has been blowing today, has cleared the atmosphere somewhat and the fog signal will be given a rest as well as the nerves of some of our citizens."

Here is how a visitor to Pilot Island Light described a foghorn: "The sound is so intense that no chickens can be hatched on the island as the vibration kills them in the egg, and it causes milk to curdle in a few minutes. Visitors at the lighthouse on foggy nights sit up in bed when the siren begins its lay and look around for their resurrection robes."

With the port of Michigan City's decline in shipping, the foghorn became obsolete and was silenced. That sound now is only a memory for the old townspeople who fished and boated along the shores of Michigan City.

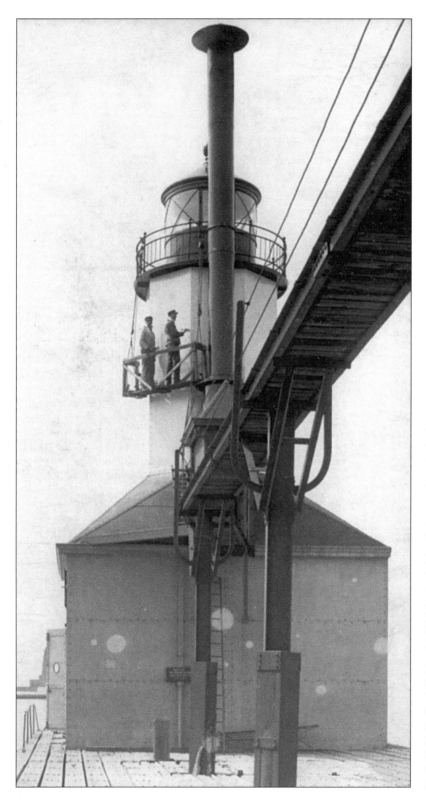

The East Pier Lighthouse is pictured at left. Tom Martin is on the left and Thomas Armstrong on the right. The back of this picture, dated May 4, 1917, reads as follows: "Your welcome letter found us all well, hope you are the same. Lottie left this a.m. for Muskegon, expects to be gone about two weeks. We are busy now with the outside painting. Some rig we have, beats the old ladder stunt, painting the signal white this year. They should take all married men first in this war for they are used to fighting."

This is a rare photo of the fog whistle blowing at the East Pier Lighthouse. This light was placed in service on October 20, 1904.

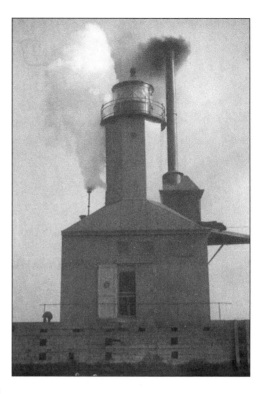

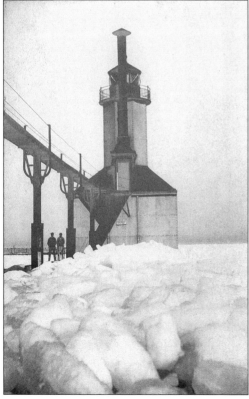

The East Pier Lighthouse is pictured here during the winter. Keeper Fred Dykeman is standing on the left with a friend.

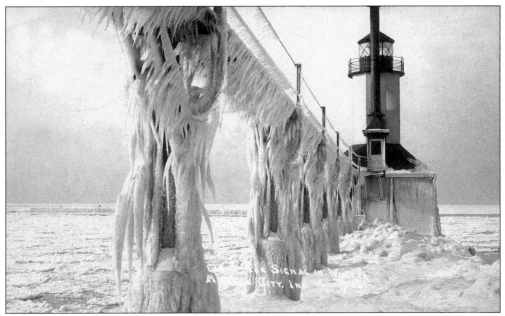

The East Pier Lighthouse was photographed in the deep winter season. This short note was dated December 27, 1917, to Fred from Tom Martin after he left the service. "Too bad you had to be laid off on account of the shortage of coal, but you were lucky to get another job right away. There is no hard coal to be had here, but there seems to be plenty of the soft, glad we have ours."

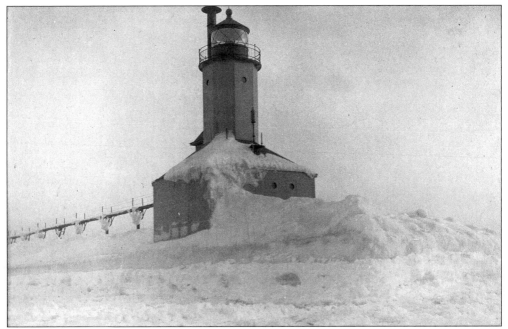

On February 15, 1910, Fred sent this photo postcard to Anna Haan in Grand Rapids. The back reads: "This is a side view of the fog signal taken on the east side of the signal. Makes a nice picture." The keepers that stayed on during the winter months had their work cut out for them as they worked to keep doors and access areas open.

The East Pier Lighthouse is shown here with Keeper Fred Dykeman standing at the door. Note the steam whistle in front and the steel plates that encased the brick.

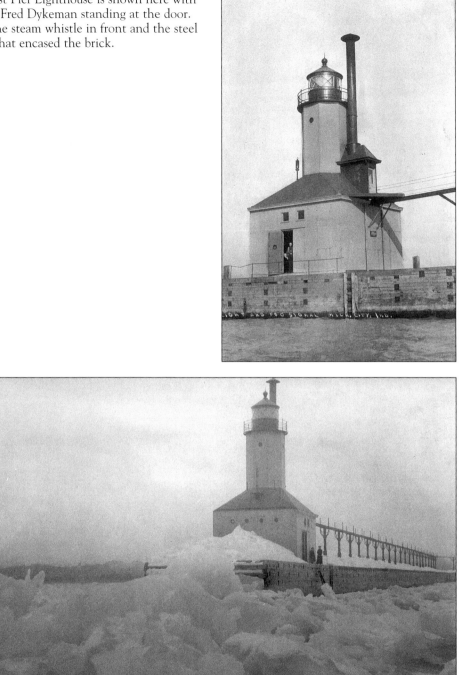

East Pier Lighthouse is pictured here. Thomas Martin's journal reads: "January 25, 1920—S.E. Light, cloudy to clear. Went out on the land and took some views, small strip of open water.

February 14—W. Fresh, Blizzard. Worked all day on a phonograph record cabinet. No open water 8 a.m. to 7 a.m."

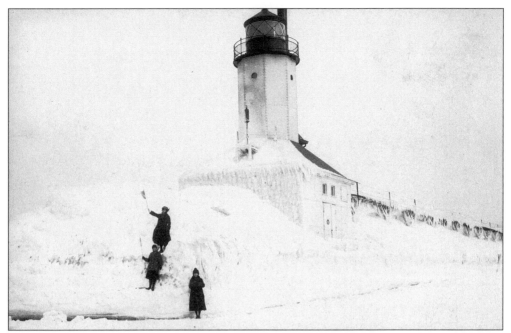

Three unidentified young women wave their American flags as they pose in front of the East Pier Lighthouse. The women are probably Thomas Armstrong's daughters Amber and Sylvia, and wife Jessie.

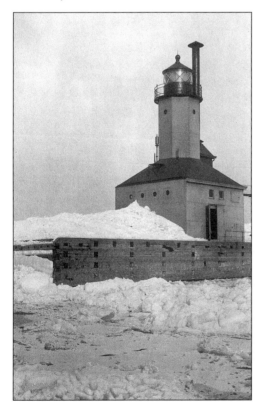

East Pier Lighthouse is pictured here. Thomas Martin's journal April 12, 1920: "N.E. Mod. To Fresh, rain and snow to cloudy. The keeper and I removed the paint from four panels in the E. Pier lantern and mixed some paint."

Nine
PHOTOGRAPHY

The heavy clouds still hung low, and the breeze was a bit nippy as Tom Armstrong and Fred Dykeman ventured out on the west pier. It was December 10, 1909, and each man's arms were tightly wrapped around their tripods with hands gripping their cases of photo plates and cameras. It was a slippery trek across the icy pier, but the end reward was well worth the trip.

Ice coated the east pier catwalk across the way and left a spectacular sculpture of shapes and colors throughout the supports. In the background, large ice banks loomed up from the beach and created a moonlike landscape, with craters and caves forming along the shoreline.

It was not just the duties of light keeping that bonded these men together, but a strong desire to capture in photos the beauty of the seasons and the events along the waterfront. It was a hobby they shared, and they were very good at it. Later in 1911, Tom Martin joined the group, and the trio set off recording history for us as it happened for them.

Their equipment of the early 1900s was a far cry from today's automatic winders, auto focus, and quick film loading. The cumbersome cameras had to be set up on very fragile wooden tripod legs. A heavy plate box of glass negatives had to be carried along, and the exposure plates slid into the camera for each photo. Their own darkroom for developing the plates was set up in a spare room in the basement of the lighthouse residence. No one-hour developing at the corner drugstore or mall was available to them.

The following is a note Fred wrote on the back of a postcard discussing their December 11 outing: "This is the west pier and it is covered with ice. Where you see the X is where we have that cable and it is covered with ice a foot wide and three to four feet high the ice that is on it. So we have no place to hang on to now. It looks just like a hedge fence from across the river, it looks great. If you notice where that X is on the tower is where the door is and you can just see the door if you look closely. As Ever, Fred Dykeman."

Because of these three keepers' photographic skills and love of the area they served, we too can catch a glimpse of a time now past, a time that will now be forever remembered.

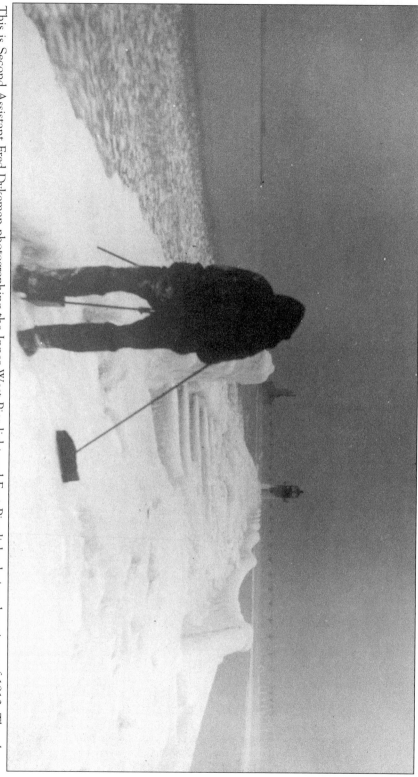

This is Second Assistant Fred Dykeman photographing the Inner West Pier light and East Pier light during the winter of 1910. The above photo is interesting, as Captain Armstrong took a picture of Fred taking a photo of the West Pier. Here is Fred's comment on the back of the photo card sent to Anna. "Do you know who this is? It is your dear old boy taking a picture and captain thought it would be great to get me on his picture at the same time. He never said a word until after he took it. I was just taking one myself and then he said I got a nice picture and I said, did you, and he said, yes, with you in it. I said it must be a dandy! Then we both laughed and I did when I saw the plate, now don't laugh, because I could not help it."

106

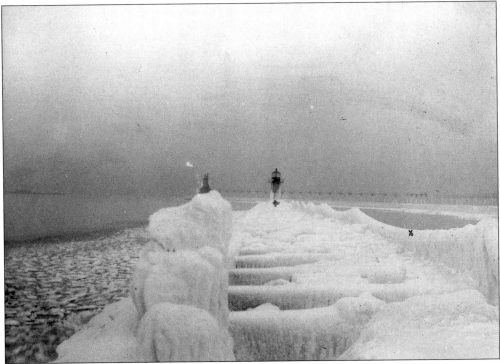

Here is a photo Fred Dykeman took of the Inner West Pier Light and the East Pier Light.

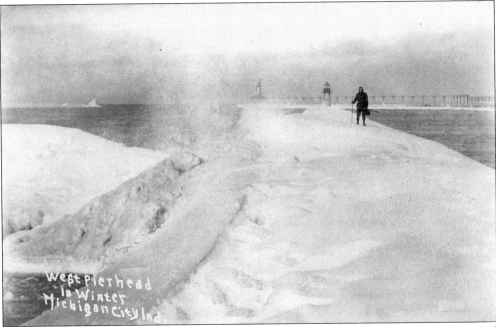

West Pierhead
In Winter
Michigan City Ind.

This is the West Pier with First Assistant Thomas Martin posing. He has his negative case and tripod in hand. All the keepers made up extra copies of their photos and sold them through the general store and other area stores. In 1920, the postcard-size prints were sold for 50¢ a dozen, and a 5-inch by 7-inch size sold for 75¢ each.

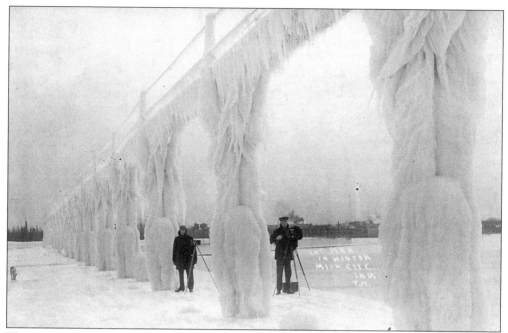

Their cameras set up on tripods, Second Assistant Keeper Fred Dykeman (left) and Keeper Thomas Armstrong (right) are ready to photograph the East Pier Light. Note the case at Tom Armstrong's feet, which held the glass negative plates.

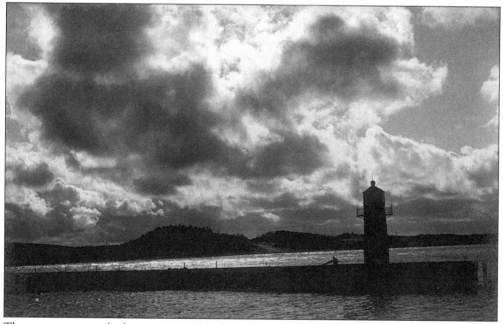

The sun sets as you look west across the channel to the Inner Pier Light Tower.

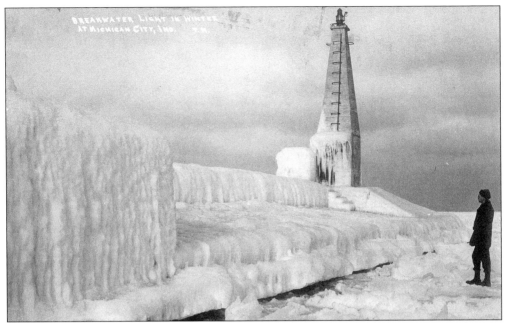

Keeper Thomas Martin stands back and surveys the ice build upon the West Pier Breakwater. Many times throughout Thomas Martin's journals, he made entries describing his opportunities to pursue his love of photography. Here are excerpts from his 1920 journal: "January 27 N.E. to N. Mod. Cloudy. Commenced to build a darkroom in the cellar. June 11 N.E. Mod. Cloudy. Came off watch at 7. Slept until noon and then printed some yacht pictures."

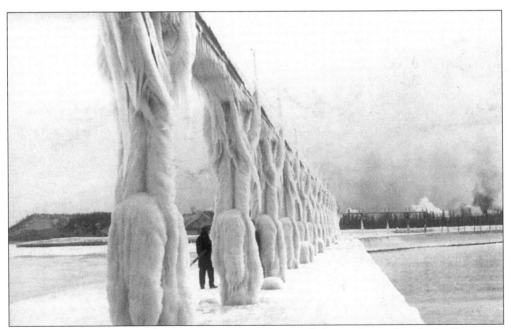

Fred Dykeman packs up his tripod and heads back toward the Michigan City Light Station to warm up after his outdoor photo session.

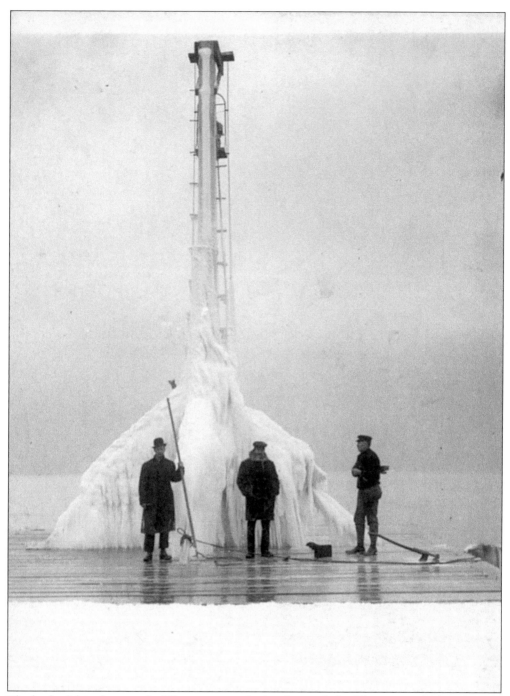

The back of this photo reads: "This picture is the breakwater light. The man with the pike pole is Charlie Marshall, the Life Saving Station man. The No. 2 and the man in the middle is Fred Ketchem, the pier inspector. The other is Thomas Armstrong, the head keeper of the lighthouse. And the fourth man you can not see as he is taking the picture with his camera. I will send you one later when Tom took me standing where I have this cross made on my picture. I slipped once to get up there but the second time I got up and stayed till I was ready to come down."

This is Fred Dykeman standing on the West Breakwater Light shortly before it was destroyed in the February 1910 storm. This photo reads: "This is me trying to get up at the light to break the ice away so we can get the lamp down. It is only up thirty feet high from the pier. Doesn't look like me at all! P.S. My camera is down on the pier right back of the ax, see it?"

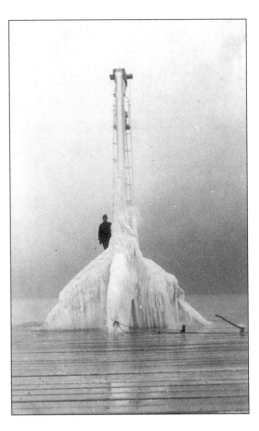

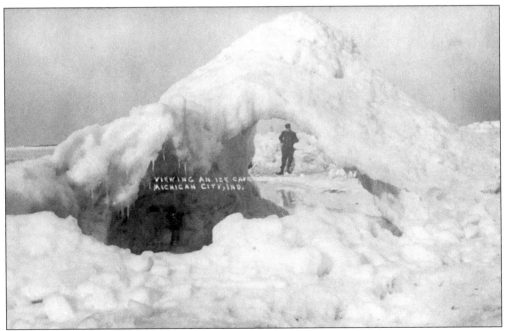

Second Assistant Fred Dykeman poses on ice caves on the Michigan City shoreline. The keepers took many photos of the ice bridges and caves along the Lake Michigan shore.

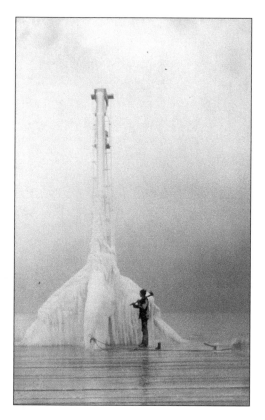

Second Assistant Fred Dykeman has his ax in hand, preparing to clear away the ice on the West Breakwater Light. The back of this postcard by Fred reads: "This is when I started to chop to get up where you see me on the other photo. All that white marks on me is snow frozen on my clothes. Great sight, is it not?"

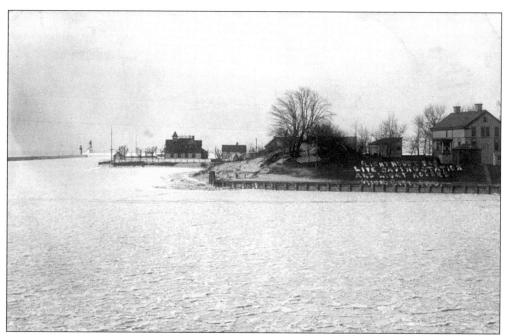

The Michigan City Lighthouse Residence is on the far right, and the U.S. Life-Saving Station is on the left. The lights are in the distance. This photo was taken in January of 1914.

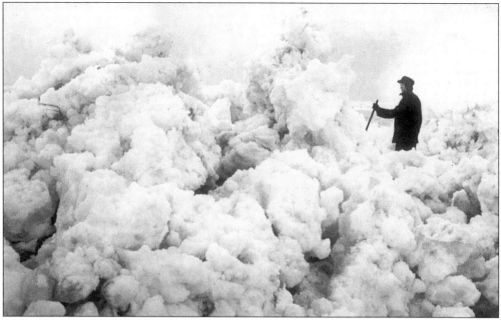

Fred Dykeman surveys the ice build-up on the lake during the winter.

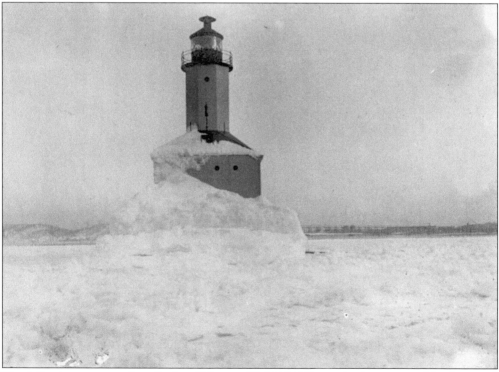

The following note was from Fred on February 10, 1910: "This is the front view of the fog signal and you can see how it is iced all up. That is ice all over the roof and you can see the portholes or windows as some call them. There is two of them clear and the other ones are covered with ice. One of them is cracked from the ice hitting against it."

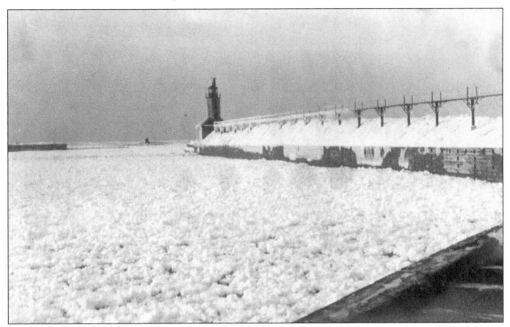

The East Pier Light and catwalk is pictured on January 31, 1910. Fred writes Anna: "Where that X is, that is a wave. Can you see it? See the ice on the roof of the building? We were out there today and everything was ok."

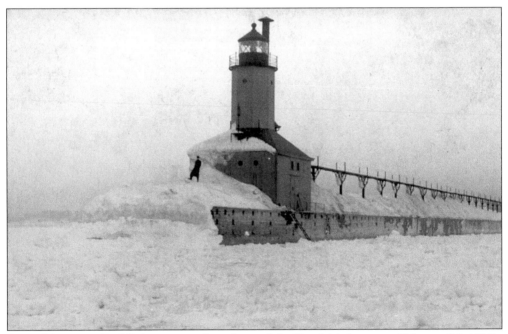

Second Assistant Fred Dykeman stands in front of the East Lighthouse on February 26, 1910.

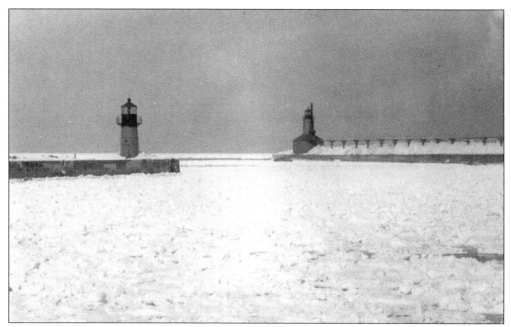

The winter of 1910 shows the Michigan City harbor frozen over. The photo from Fred reads: "This is a new view taken of the West Pier Light and fog signal. You have one something like it, but the one you got takes in the whole pier with all the tram way on it. The views are almost alike, but taken in different ways."

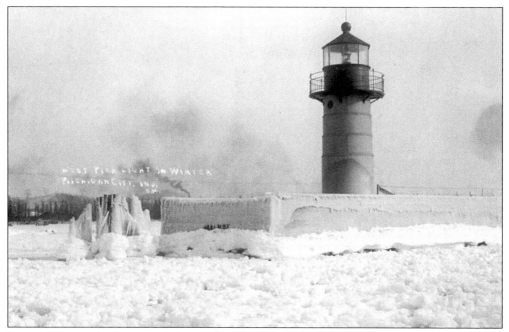

Pictured here is the front of the Inner West Pier Tower looking east toward the shore.

Shown here is the Michigan City Harbor looking north. The building on the right is the boathouse for the U.S. Lighthouse Service.

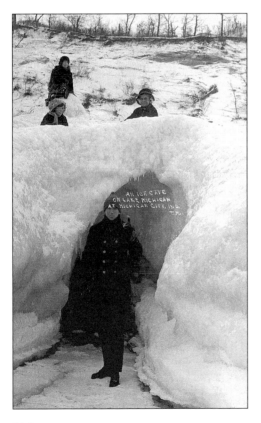

Keeper Fred Dykeman is standing in the ice cave, while Sylvia and Amber Armstrong look on.

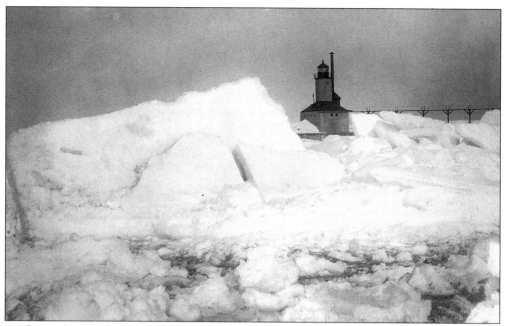

Ice flows pile up in the harbor entrance during a severe winter at Michigan City.

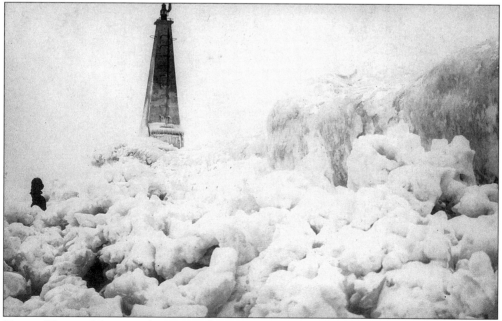

Keeper Thomas Martin is shown standing on mounds of ice that built up on the West Pier Breakwater.

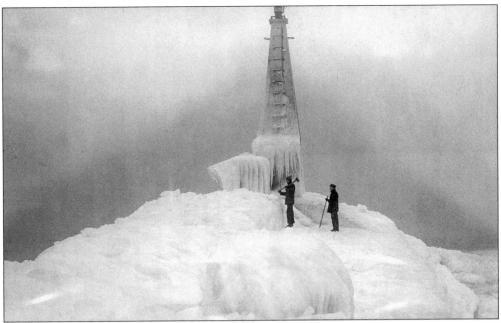

Light Keepers Thomas Martin, on the left, and Thomas Armstrong, on the right, check the amount of ice on the access door on the West Breakwater Light.

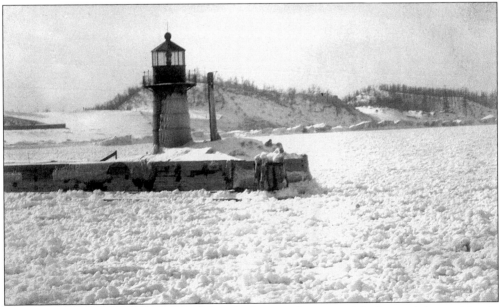

The West Inner Pier Light is pictured here looking to the west, with the sand dunes rising in the background.

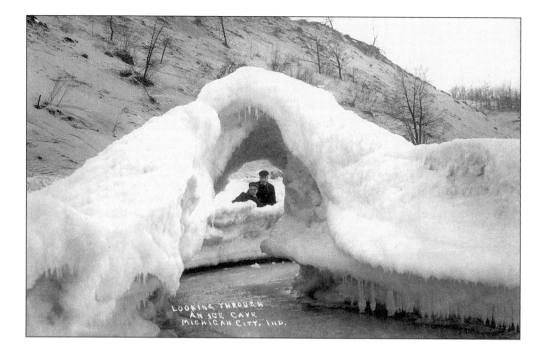

Keepers Thomas Martin and Fred Dykeman pose behind an ice cave on the Lake Michigan shoreline. This excerpt is from Keeper Martin's journal on December 19, 1920: "W. Mod. Cloudy. The ice banks commenced to form on the W. beach and a small amount of slush ice came in to the harbor. The kids were skating near shore on the basin."

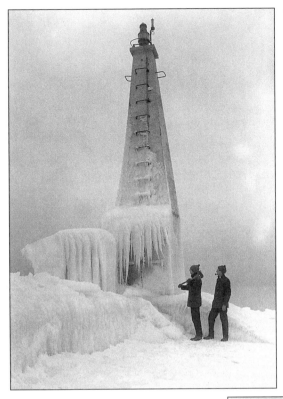

Lightkeepers Fred Dykeman and Thomas Martin contemplate how to chop away the ice on the West Breakwater Light.

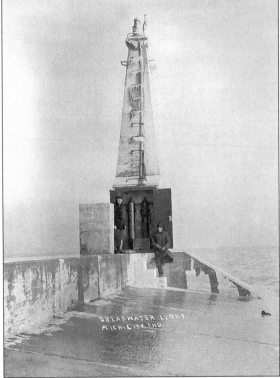

The West Pier Breakwater Light is pictured here. The keepers are servicing the gas cylinders, which you can see as you look into the door. Keeper Thomas Armstrong is on the left and Fred Dykeman is seated on the right.

Thomas Martin's journal reads: "May 3, 1920, N.E. to Mod. Clear. The keeper and I painted the West Pier lantern and tower. Went to the dentist and had an impression taken of my gums."

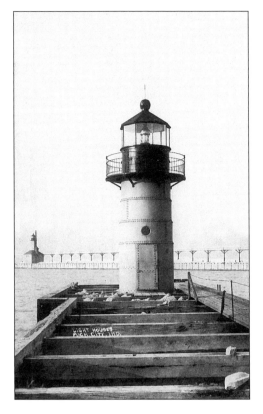

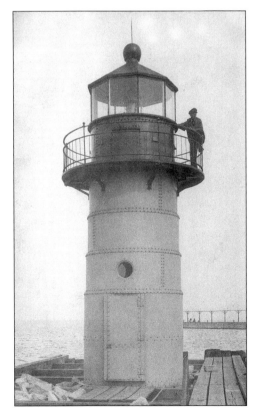

An excerpt from Martin's journal reads: "September 30, 1920—N.E. Fresh. Rainy. The West Pier Light went out at 12 mid. I walked around and turned on a new tank and lit the light. The keeper and I went over and put in a new tank after breakfast. N.E. gale, worst blow of the season." The keeper leaning on the railing is Second Assistant Fred Dykeman.

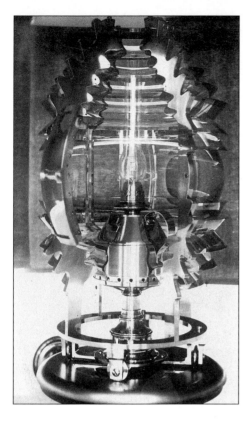

The lens is a Fifth Order Fresnel fitted with a brass reflector. It covers 90 degrees, and produces an arc of illumination of 270 degrees. Here you can see the inside of the lens with a section removed.

Pictured at right is the Fifth Order Fresnel lens, manufactured by Sautter and Company of Paris, France. The picture, taken by Fred Dykeman, is from inside the East Pier Lighthouse. These lenses, other equipment, and supplies were brought to the light stations by the lighthouse tenders.

122

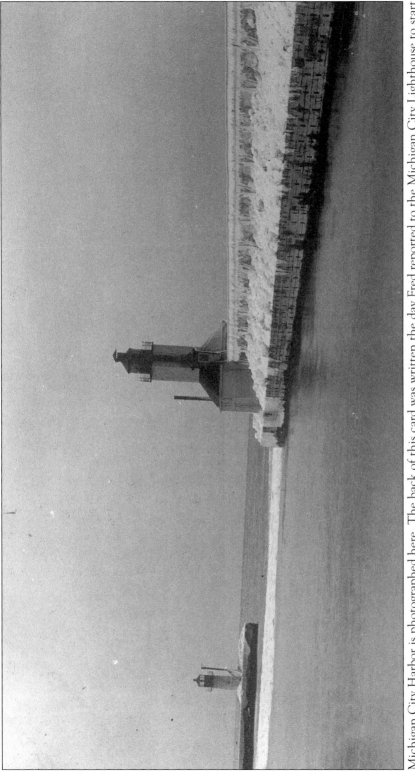

Michigan City Harbor is photographed here. The back of this card was written the day Fred reported to the Michigan City Lighthouse to start his lighthouse career on July 5, 1909: "I will have to be on watch at 7 in the morning and it is a nice place. Did you have a good time at Holland?"

The above photo was explained by Fred: "This is the signal and breakwater. Don't they look nice? You can see the young ice in the harbor. We went through that with our boat to get some outside views but they are not very good. Took them from the boat but it was not still enough and too dark to take a snap shot. These were taken on the piers."

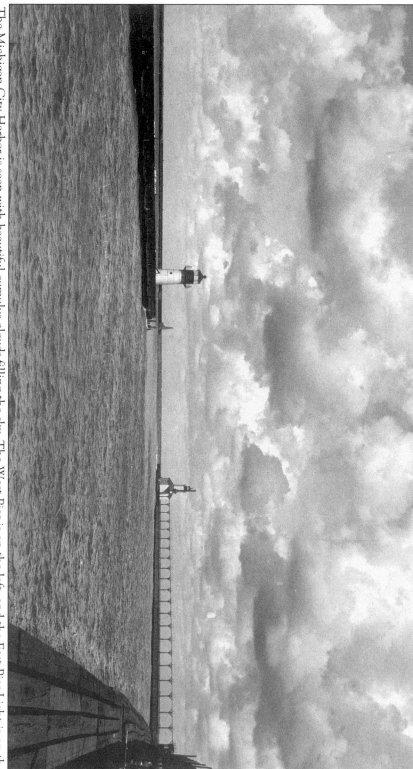

The Michigan City Harbor is seen with beautiful cumulus clouds filling the sky. The West Pier is on the left, and the East Pier Light is on the right. The catwalk and lighthouse had some improvements made in 1894, and the Michigan City Enterprise had this to say: "The beacon has been comfortably filled up and furnished with a small stove, for the convenience of the keeper, and to keep the oil in proper condition. The walk is 1,362 feet in length and will afford great facilities for lovers who believe that two is company and three none, as they stroll arm in arm under 'the bright silver light of the moon' in the season of the year. A gondola at the steps, and, particularly, a toll-gate at the foot of the walk, would do a thriving business."

124

This front view of the Michigan City Lighthouse Residence was taken by Fred Dykeman from Washington Park. The west side of the dwelling looked out over the big lake and the bend in the river. Inside the residence there were three levels. The first level contained the kitchen and wood-burning cook stove. Next to this room, underground, were the dining room, laundry, and shop. The main floor of the lighthouse residence contained the living room with a large entry hallway, with a beautiful wood stairway leading to the third floor. A bathroom and bedroom were also on this level. The upstairs had two bedrooms and a bathroom. The electricity and the plumbing were not installed until about 1933.

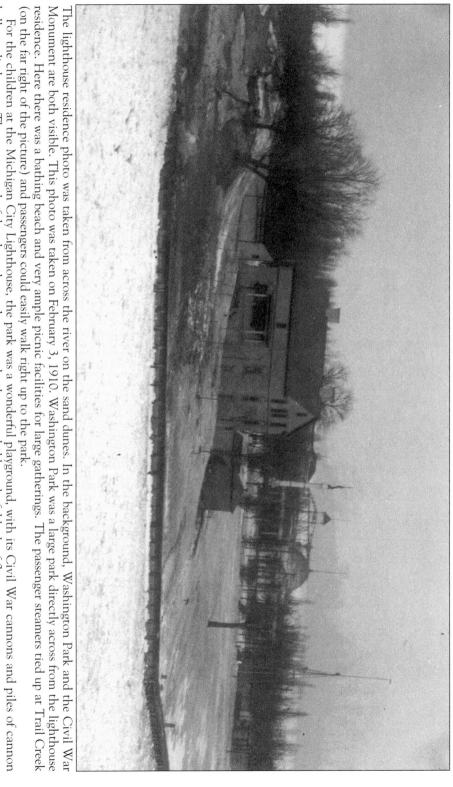

The lighthouse residence photo was taken from across the river on the sand dunes. In the background, Washington Park and the Civil War Monument are both visible. This photo was taken on February 3, 1910. Washington Park was a large park directly across from the lighthouse residence. Here there was a bathing beach and very ample picnic facilities for large gatherings. The passenger steamers tied up at Trail Creek (on the far right of the picture) and passengers could easily walk right up to the park.

For the children at the Michigan City Lighthouse, the park was a wonderful playground, with its Civil War cannons and piles of cannon balls to climb over. There was a colorful rock garden and a water wheel surrounded by colorful beds of flowers.

In the summer, the marches of John Phillip Sousa could be heard coming from the bandstand as an evening concert was being presented to an enthusiastic crowd of onlookers.

126

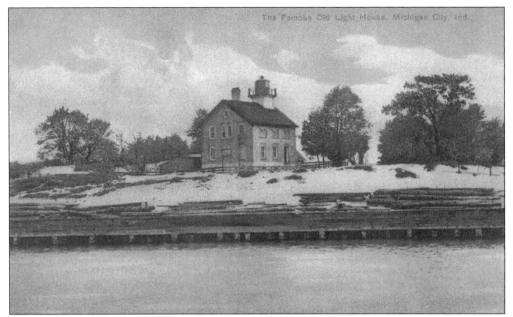

The above postcard shows the Michigan City Lighthouse as it appeared when it was built in 1858. In 1904, the lighthouse was remodeled and enlarged into the lighthouse keeper's residence. The lantern was removed and placed on the new East Pierhead Light. Keeper Fred Dykeman sent this post card to Anna Haan, who lived in Grand Rapids, Michigan, when he was courting her.

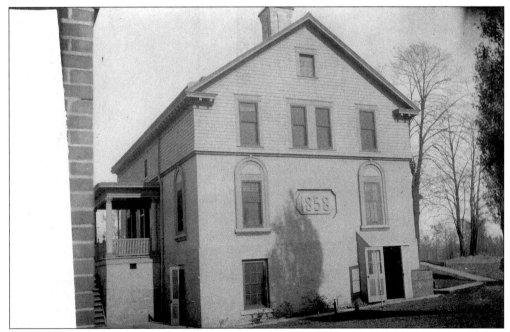

Pictured here is the south end of the lighthouse residence in November of 1909, taken by Fred Dykeman. "Just got through with supper. It is now 6:45 and will get ready to leave here at 7 o'clock for town, as we are not supposed to leave till our watch time is up."

BIBLIOGRAPHY

Barcus, Frank. *Freshwater Fury*, 1960.

Dispatch News, January 28, 1983. "Only Lantern Marked City Harbor."

The Evening Dispatch, November 13, 1905. "Larger Fog Horn in Station Here."

———, December 9, 1905.

The Grand Rapids Press, August 14, 1983. "Saugatuck Family Shedding Light on Lighthouse Lore."

———, January 31, 1997. "100 Years in America."

Greenwood, John. *Namesakes II*, 1973.

———. *Namesakes 1930–1955.*

———. *Namesakes 1920–1929*, 1986.

———. *Namesakes 1910–1919*, 1986.

Hyde, Charles K. *The Northern Lights, Lighthouses of The Upper Great Lakes*, 1986

Lane, Kit. *The Dustless Road to Happyland, Chicago—Saugatuck Passenger Boats, 1859–1929,* 1995.

Lighthouse Digest, March 1999.

———, August 1995.

Merchant Vessels of the United States, 1905 Government Printing Office.

Noble, Dennis L. *The Old Life-Saving Station at Michigan City, Indiana. 1889–1914*, Indiana Historic Bulletin.

Robert, Bruce and Jones, Ray. *Western Great Lakes Lighthouses, Michigan and Superior*, 1996.

Shanks, Ralph. *York, Wick, Shanks, Lisa Woo*. The U.S. Life-Saving Service, 1996.

Sheridan, Sarah. *Memories of the Michigan Lighthouse*, 1991.

Stonehouse, Fredrick. *Wreck Ashore*. "The United States Life-Saving Service on the Great Lakes," 1994.

Tag, Phyllis L. and Thomas A. *The Lighthouse Keepers of Lake Michigan.*

Van der Linden, Peter J. Rev. *Great Lakes Ships We Remember*, 1979.